PENNSYLVANIA

A Photographic Journey

Dedicated with love to
my wife, Susan,
and son, Joe
and also
to the memory
of my loving parents,
Walter & Anna
Choroszewski

PENNSYLVANIA

A Photographic Journey

———

WALTER CHOROSZEWSKI

AESTHETIC PRESS, INC.
Somerville, New Jersey

PENNSYLVANIA, *A Photographic Journey*

Designed by Walter Choroszewski
Printed in Korea
5 4 3 2 1

ISBN: 0-933605-15-3

AESTHETIC PRESS, INC.
P.O. Box 5306, Somerville, NJ 08876-1303

Web: www.aestheticpress.com
Email: info@aestheticpress.com
Telephone: 908 369-3777

Cover:
Neff Round Barn,
Potter Township,
Centre County

Half Title:
Allegheny Mountains,
Bedford County

PENNSYLVANIA
A Personal View

WALTER CHOROSZEWSKI

"God's Country" is how my family described the beauty and bounty of Pennsylvania. I agree, there is no better expression for this state.

My immigrant grandparents arrived in the early part of the 20th century from Poland and Slovakia, seeking employment in the thriving anthracite coal fields of northeastern Pennsylvania. It was a hard life for them—yet somehow the stories that were passed on to me were upbeat and filled with hope and with gratitude for the freedoms and opportunities they found in Pennsylvania.

Both my grandfathers were coal miners, as was my father, and I grew up in the very small "Patch Town" of Jeddo—one of the company towns created by the Jeddo-Highland Coal Company. Interestingly, my father was from the village of Highland and my mother was from Jeddo. My father's brother, Uncle Stanley—a wonderful teller-of-tall-tales—convinced me that as a tribute to my father, the coal company changed its name to honor my parents' marriage. I believed it!

Immigrants from many European countries worked in the mines. They brought to Pennsylvania their unique customs and strong religious beliefs. Steeples and onion domes of numerous churches reached skyward from the mountainous perch of Freeland—a slightly larger town which was hub to the smaller surrounding hamlets of this coal region. The symphony of bells from St. Casimir's, St. John's, St. Ann's, St. Mary's, St. Michael's and others, pealed into these nearby villages on Sunday mornings.

In the 1950s and 1960s coal was dethroned as "king" and underground mining was being replaced by more efficient "strip-mining" techniques. Like alien spacecraft, new colossal earth-moving machines ripped open the once lush valleys to extract the treasured coal, leaving behind a barren, scarred landscape not unlike the surface of the moon or some distant planet.

My childhood friends and I would explore this intergalactic playground with imaginations larger than the mountainous coal and slate piles on which we climbed. As President Kennedy declared his mission to put a man on the moon before the end of that decade, we pretended we were already there, playing astronauts, geologists and paleontologists—looking for fossils, crystals and "fool's gold."

In addition to the towering power shovels, trucks and loaders that traversed the anthracite landscape, the town of Jeddo faced a feeder track of the Lehigh Valley Railroad. The sight and sounds of diesel locomotives pulling small strings of coal cars to and from the Harleigh #7 coal breaker was a daily event. Many people sat on their front porch swings to watch the trains. Of course, everyone would wave at the train—and did so with each and every passing—it was a friendly town!

Trains provided entertainment. As children we would place pennies on the rails and wait for the passing train to flatten them to the size of a half dollar. As teenage hoboes we would often "hop" the trains for a ride to the Hazle Brook Tunnel, then walk home—rail-walking for miles with the balance of experienced tight-rope walkers. Trains sometimes gave us weather forecasts. *"Sounds like rain is moving in,"* my father would say, as he detected a difference in the pitch of the whistle from the locomotive as it trumpeted its arrival at the Stockton Road crossing a few miles away.

A fascination with railroads continued with my own son, Joe, who seems to have inherited my interest in trains. When Joe was a young child, my wife and I would take him on some of Pennsylvania's steam excursions—Strasburg, Lackawanna, and New Hope & Ivyland, and on the famous inclines at Johnstown and Pittsburgh. Our travels to Pennsylvania often included visiting the numerous rail sites such as the Kinzua Trestle, Horseshoe Curve, Steamtown and Jim Thorpe.

If my father had not been a coal miner and he had the opportunity to choose a different occupation, I truly believe he would have been a farmer. He thoroughly enjoyed tending to his fruit trees, vegetable and flower gardens, which were quite productive despite the obstacles of a short growing season and poor soil.

Just beyond the coal and rails, fertile farm valleys abounded. On Sunday afternoons, Uncle Frankie would take my father and me for a drive to individual farms where we would purchase their summer produce for canning, their fall apples and potatoes, or winter's hay, fertilizer and seedlings for the next season's planting. A certain farmer made the best "scrapple" and smoked bacon, while another featured buttermilk and fresh brown eggs.

Sometimes we took longer trips to see the farms of the Pennsylvania Dutch and Amish communities in Berks and Lancaster Counties. The annual agricultural fairs at Bloomsburg or Kutztown were important events for us. Together we enjoyed seeing the livestock, reveling in the giant prize-winning pumpkins, and eating the smorgasbord dinners and Pennsylvania Dutch funnel cakes.

As a child, my small-town perspective was greatly expanded when new superhighways were built nearby. Finally, civilization had found us—gone would be the days of party lines and outhouses. The Pennsylvania Turnpike's northeast extension had finally reached into the Poconos, but it wasn't until the early 1960s when America's interstate highway system truly blossomed. Excitement was in the air because we lived near the newly proclaimed "Crossroads of America"—the intersection of Routes 80 & 81, highways which were supposed to bring new life to the region's depressed economy.

During summer vacations, my Uncle Joe, who lived in New Jersey, would come back to Jeddo and would take me away on these new superhighways to adventures in New York and the Jersey Shore. We would sometimes visit my Aunt Mary who lived in Philadelphia where I discovered yet another side to Pennsylvania—one featuring history, art, culture and the city life.

When I was finally old enough to drive, I also journeyed on the same highways to discover more of Pennsylvania— west on Route 80 to State College; north on Route 81 to Wilkes Barre and Scranton, and south to Harrisburg and Gettysburg. The Pennsylvania Turnpike took me south to Allentown and Philadelphia, or west to Pittsburgh (the vastness of Pennsylvania was quite evident after this 6-hour drive across the state).

My hometown was actually located on the western edge of the Poconos where my love of the outdoors grew in its forested hills and along its scenic waterways. Picking berries on Green Mountain, hiking through Boulder Field, camping at Hickory Run, climbing the falls of Ricketts Glen, fishing the Lehigh River, and boating at the Francis Walter Dam—all are cherished memories for me.

During my college years at Penn State I first discovered central Pennsylvania's natural wonders in a region where the Appalachian Mountains were forced to turn their course eastward creating an intricate topography featuring grand vistas and long limestone valleys. The trout fishing only got better at Fisherman's Paradise and Penn's Creek. Exploring the wilds of Black Moshannon, Hyner View or Sproul Forest only reaffirmed my love of the outdoors.

One summer job took me to the southwestern corner of the state to the Laurel Highlands of Somerset County. The following summer was spent in the northeastern corner, near Dingmans Ferry, on the eastern edge of the Poconos overlooking the upper Delaware River. Both summers, I lived in State Parks and basked in the natural wonderland that surrounded me. It was also the time when I first began photographing the scenic beauty and wildlife of Pennsylvania with my first camera purchased with graduation gift money.

During that summer at Dingmans Ferry I met Susan, a girl from New York who would later become my wife. Soon afterward I followed my heart and moved to New York City—it was a major change of environment! Frequent visits to my family quenched my thirst for nature as I drove home through the magnificent stone corridor of the Delaware Water Gap and across the familiar Pocono Plateau.

I'll never forget another summer's employment doing clean-up work in the Wilkes Barre area after the devastating floods from Hurricane Agnes. The overflowing Susquehanna River wreaked havoc along its entire path during the summer of 1972. After seeing the awesome forces of nature and the resulting losses, I grew more thankful for my own humble blessings. During that crisis I also witnessed the true goodness of the many Pennsylvanians who came to help, especially the Mennonite groups who joined in the clean-up effort and offered food and a tireless helping hand to all.

Hard work seemed to be a way of life in Pennsylvania— from the difficult mining life of my father to the numerous years my mother spent as a seamstress in a McAdoo textile factory. My parents wanted a better life for me so I majored in Biology with a career goal of medicine. Although my science education was invaluable to me, it was soon after graduating that I found my true calling in the arts through photography.

For over twenty-five years I have been fortunate to make a career as a location photographer, specializing in the Mid-Atlantic region, while living in Pennsylvania's neighboring states of New York and New Jersey. Photo assignments have taken me across the country, yet time and again, I find myself—both photographically and emotionally—journeying to Pennsylvania where I continue to seek, discover and appreciate the wonders of the Keystone State.

Although I have lived in three states, approximately a third of my life in each one, when people ask where I am from, my gut reply is often "Pennsylvania"—my native state. Perhaps one day the circle of life will return me home to Pennsylvania.

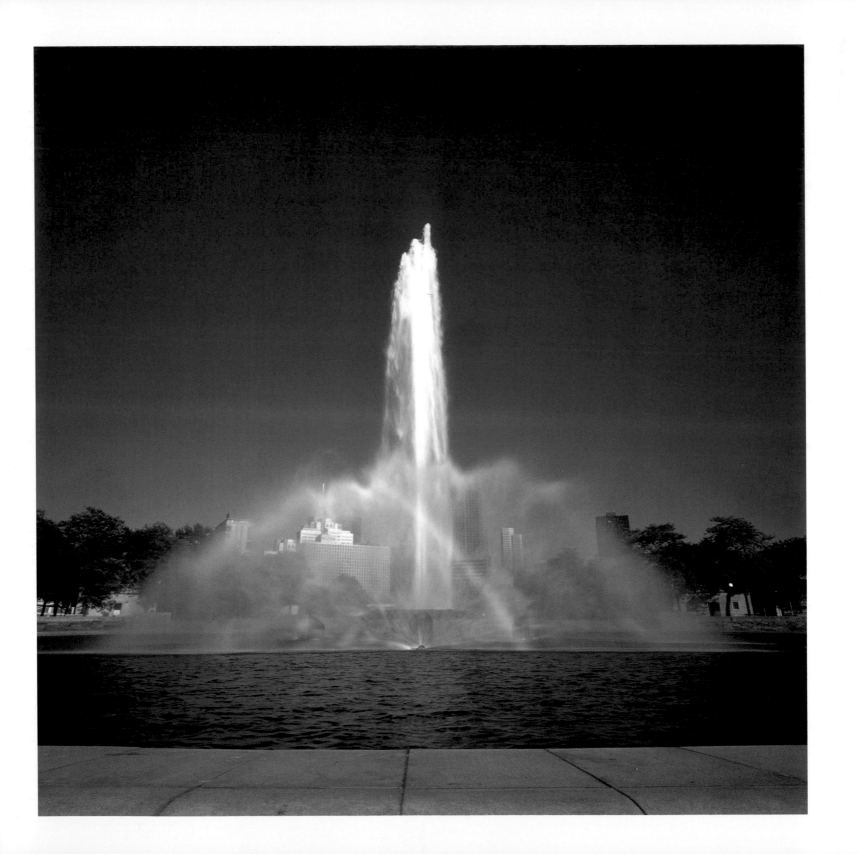

8. Fountain,
Point State Park,
Pittsburgh

9. Swann Memorial
Fountain, Logan Circle,
Philadelphia

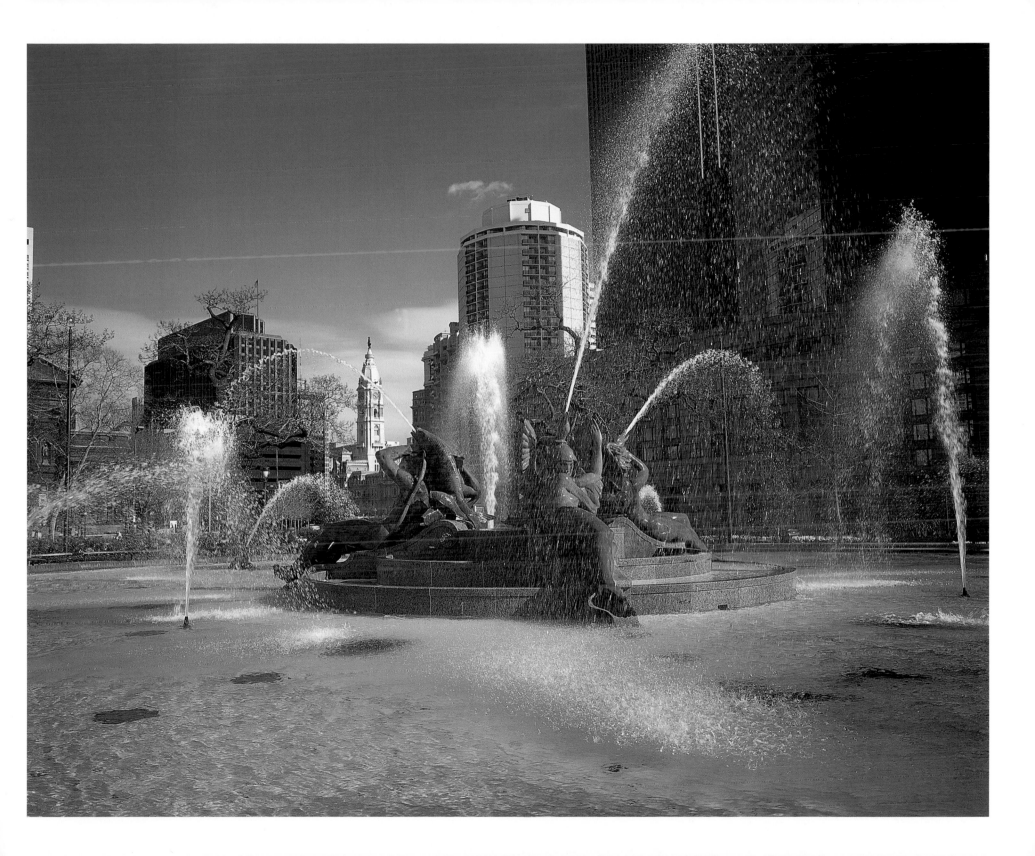

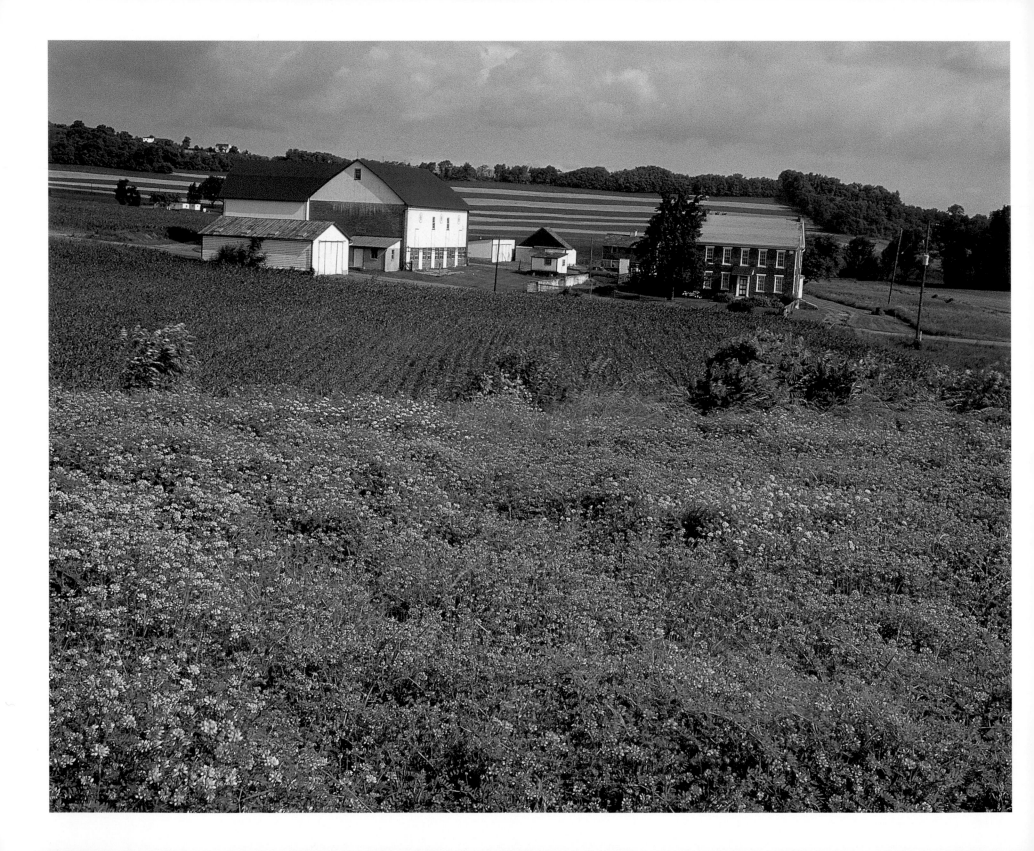

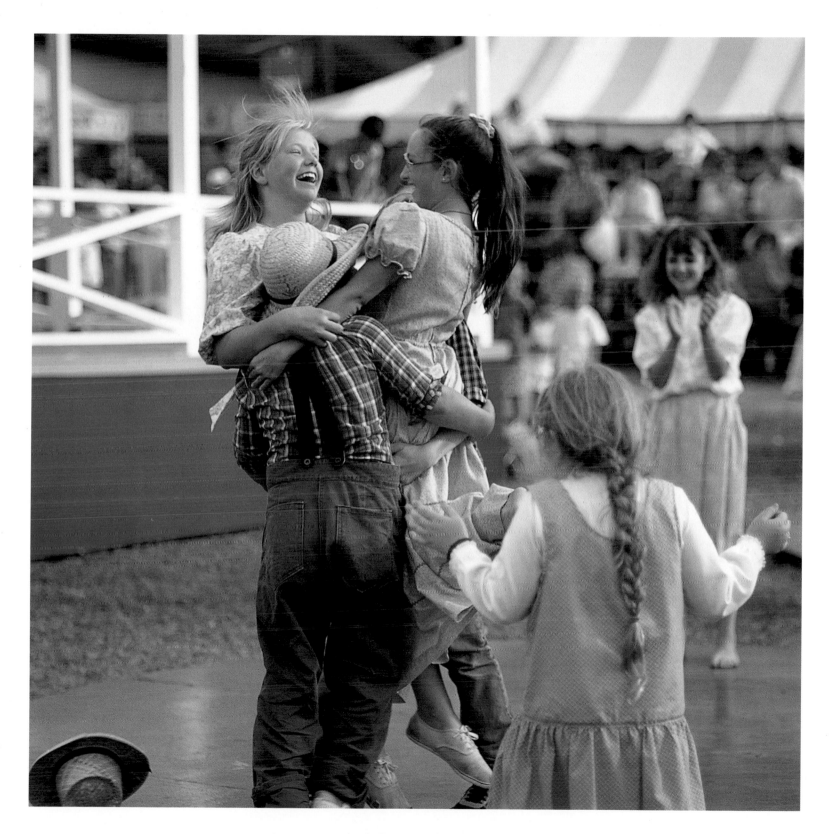

10. Kutztown, Berks County

11. The Kutztown Festival,
Kutztown, Berks County

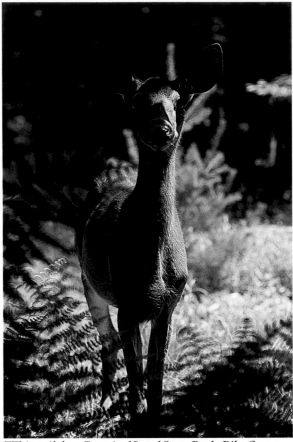

Whitetail deer, Promised Land State Park, Pike County

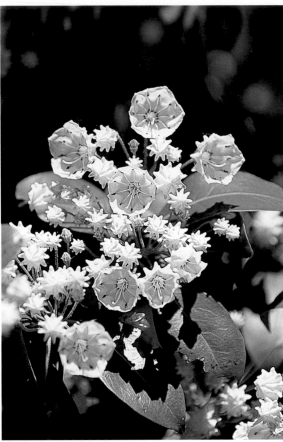

Mountain Laurel, Tyler Arboretum, Delaware County

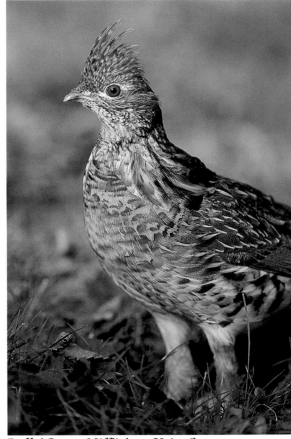

Ruffed Grouse, Mifflinburg, Union County

12. Pennsylvania's symbols

13. Capitol Dome, Harrisburg

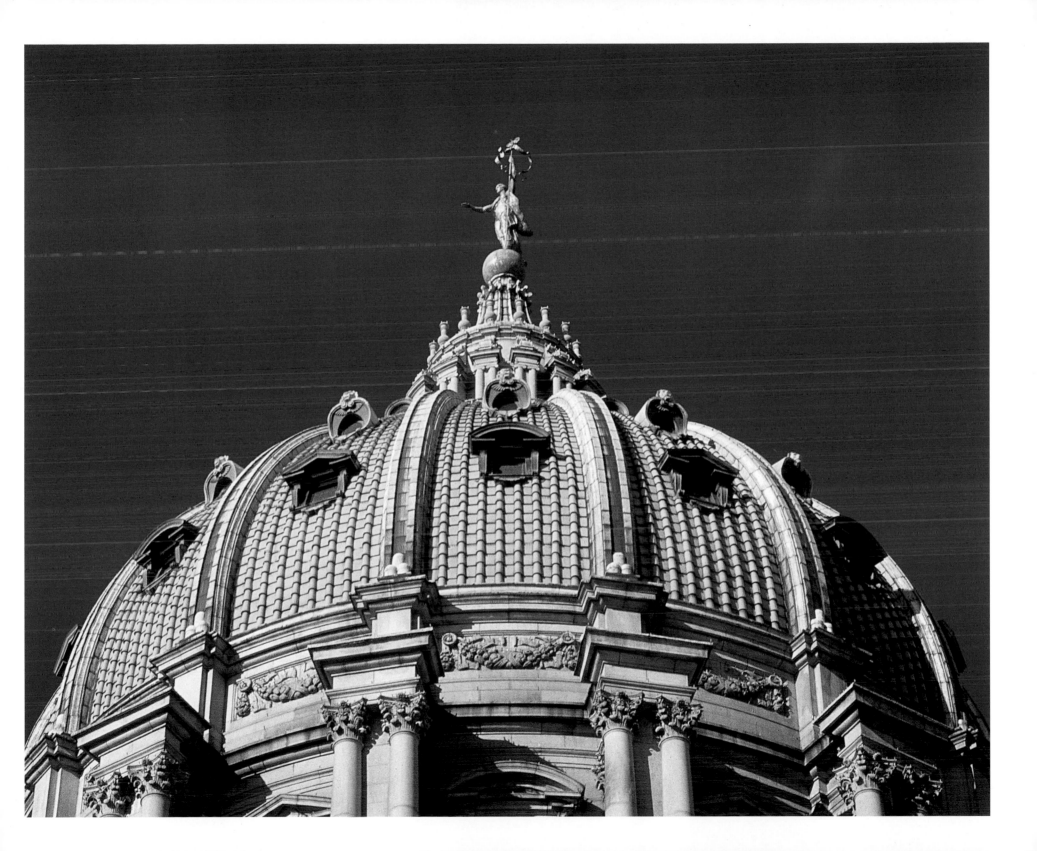

14. Dimmick Memorial Library,
Jim Thorpe

15. Cornwall Iron Furnace,
Lebanon County

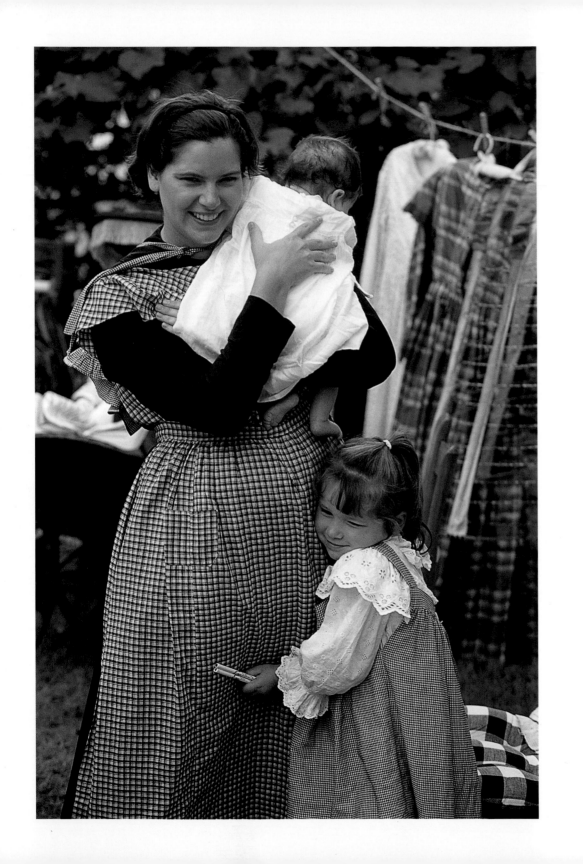

16. Family time,
Rehrersburg

17. Walking home from school,
Lancaster County

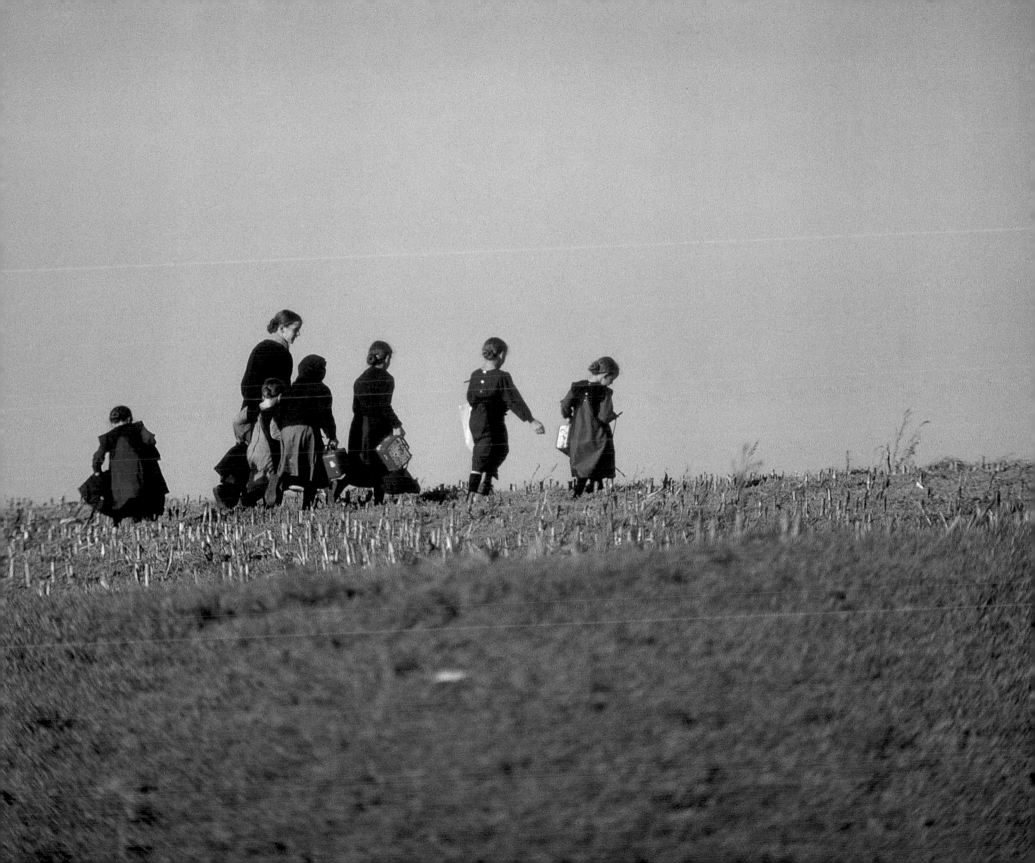

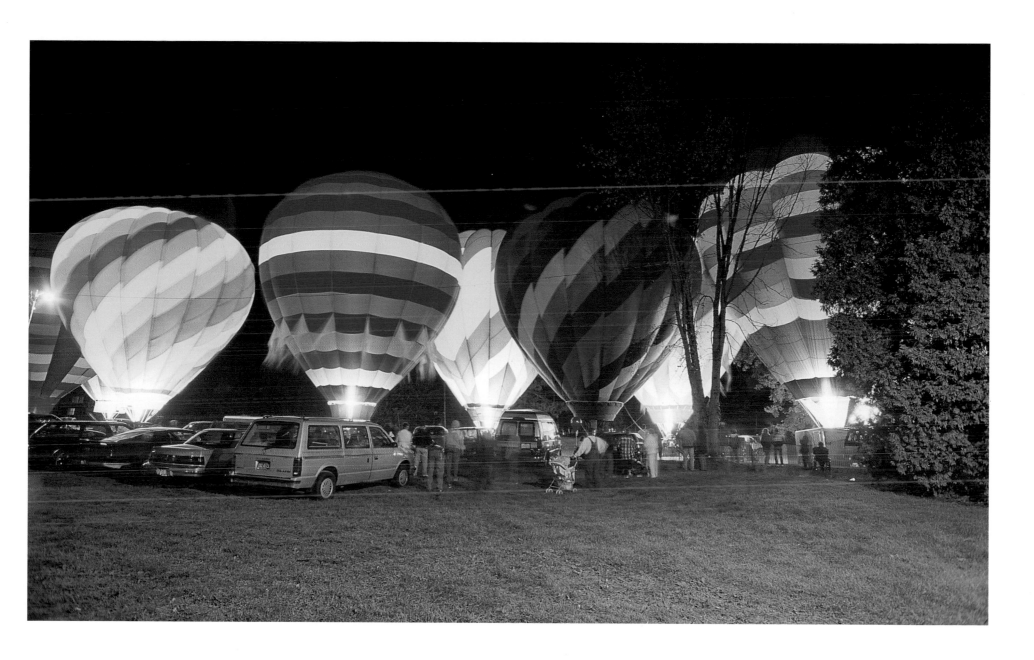

18. "We Love Erie Days," Erie

19. Pocono Balloon Festival,
Shawnee-On-The-Delaware

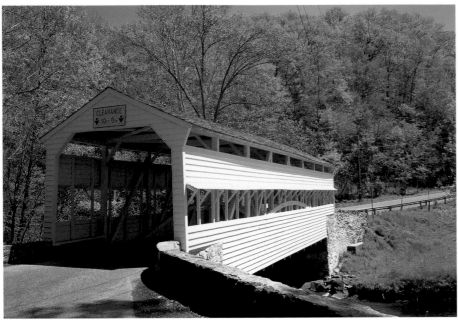

Knox Bridge, 1865, Valley Forge, Chester County

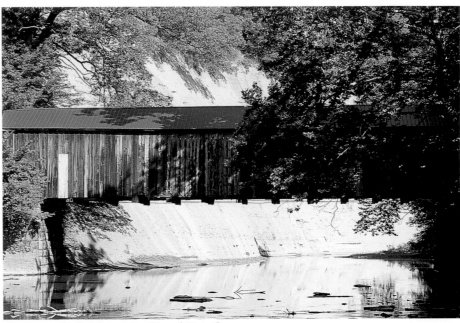

Gudgeonville Bridge, 1868, Girard, Erie County

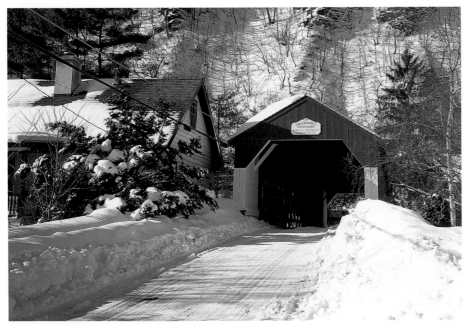

Uhlerstown Bridge, 1832, Tinicum, Bucks County

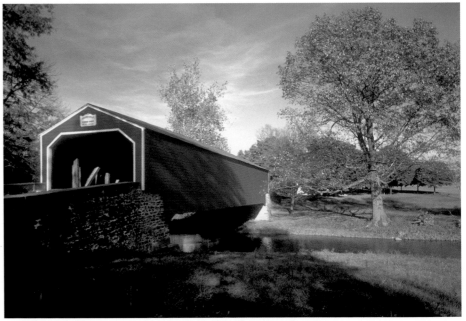

Kreidersville Bridge, 1839, Kreidersville, Northampton County

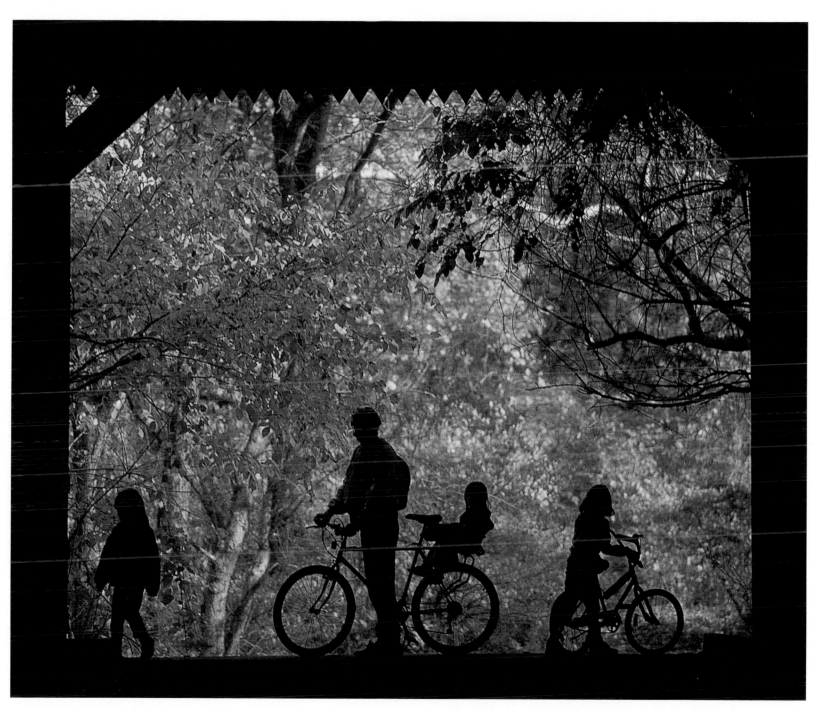

20. Pennsylvania
covered bridges

21. Thomas Mill Bridge, 1855,
Fairmount Park, Philadelphia

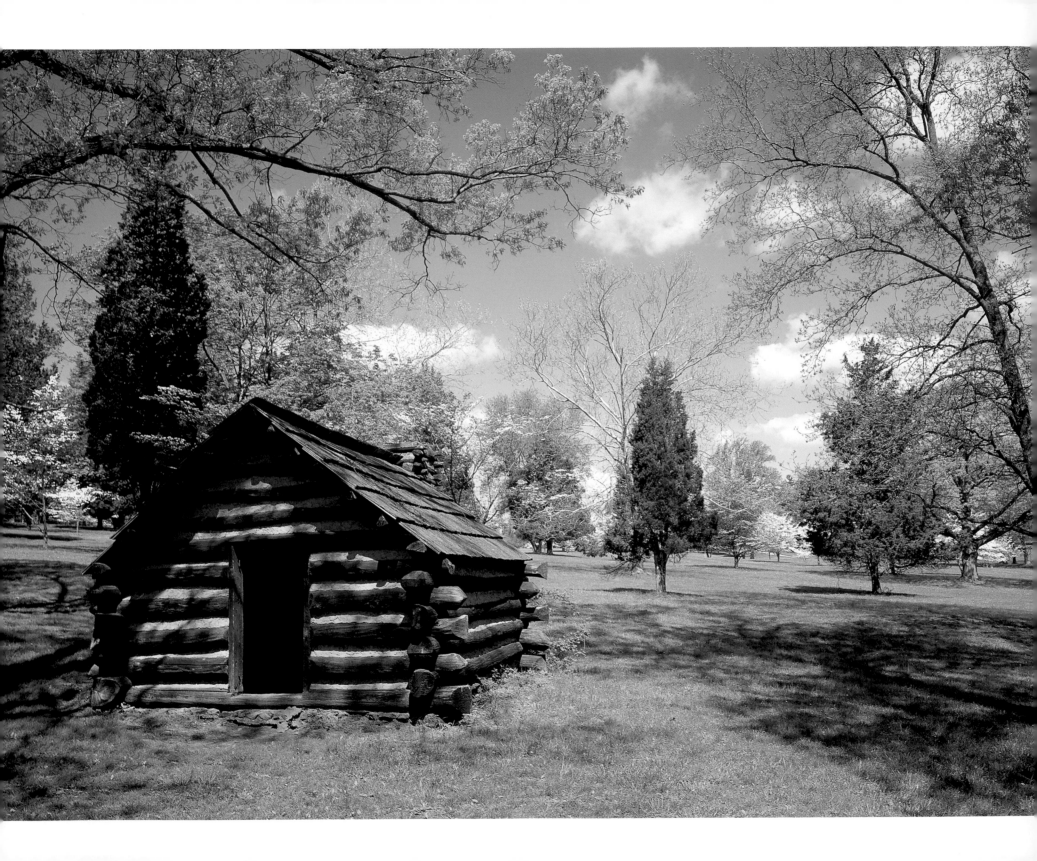

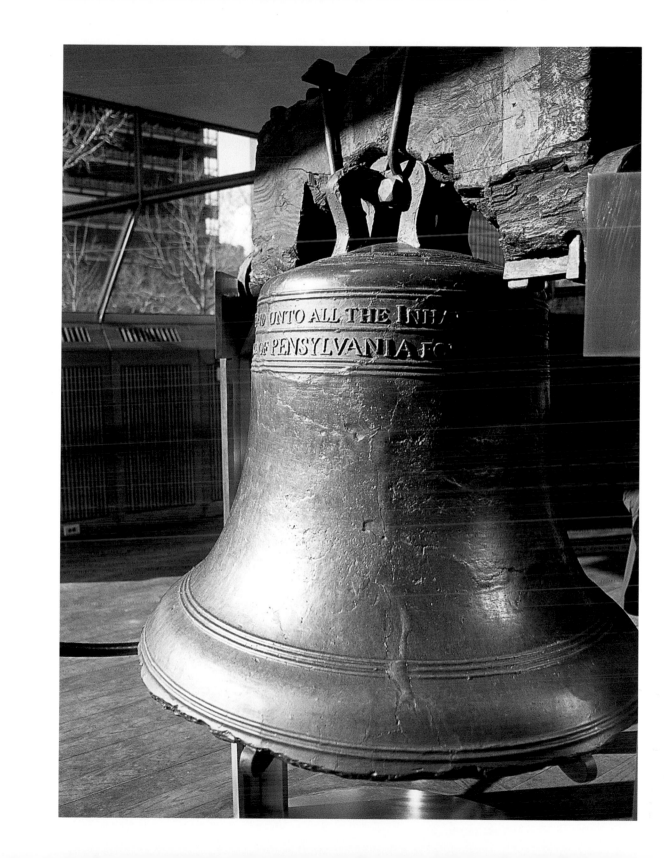

22. Valley Forge National Historical Park,
Montgomery County

23. Liberty Bell,
Independence National Historical Park,
Philadelphia

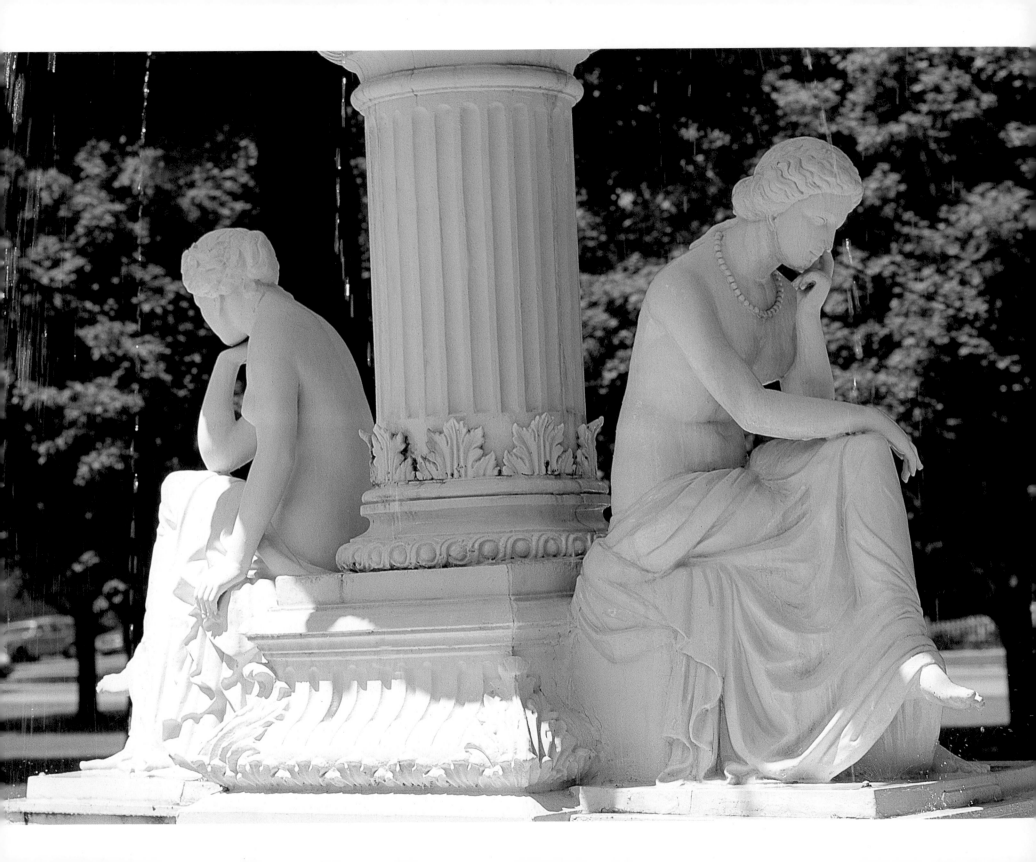

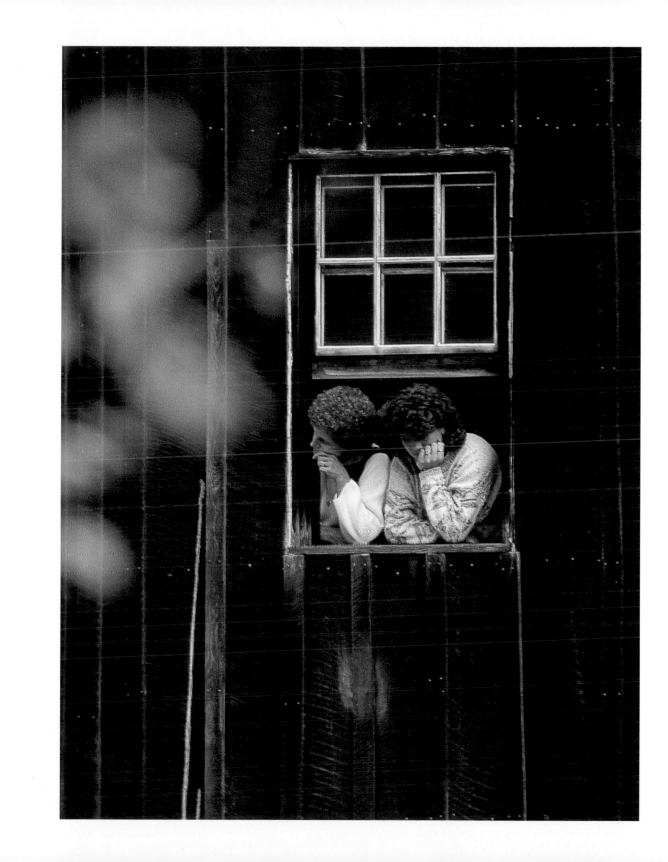

24. Egbert Memorial Fountain,
Fountain Park, Franklin,
Venango County

25. McConnell's Mill,
Lawrence County

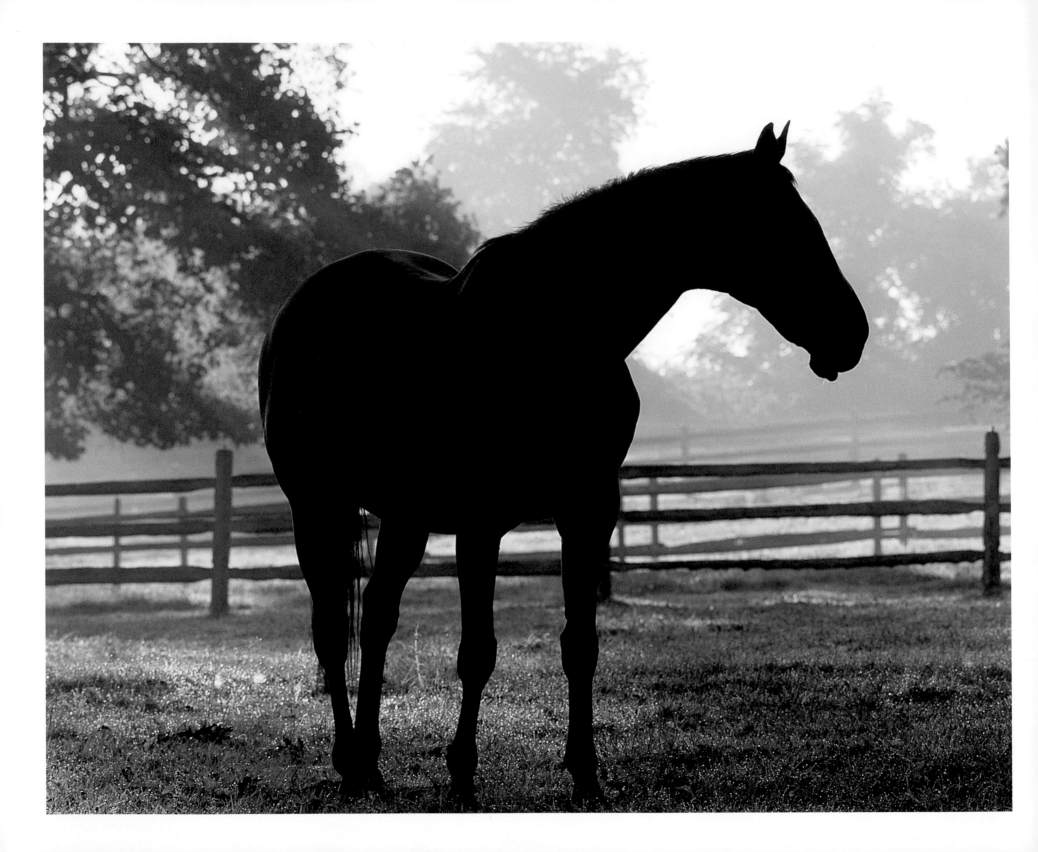

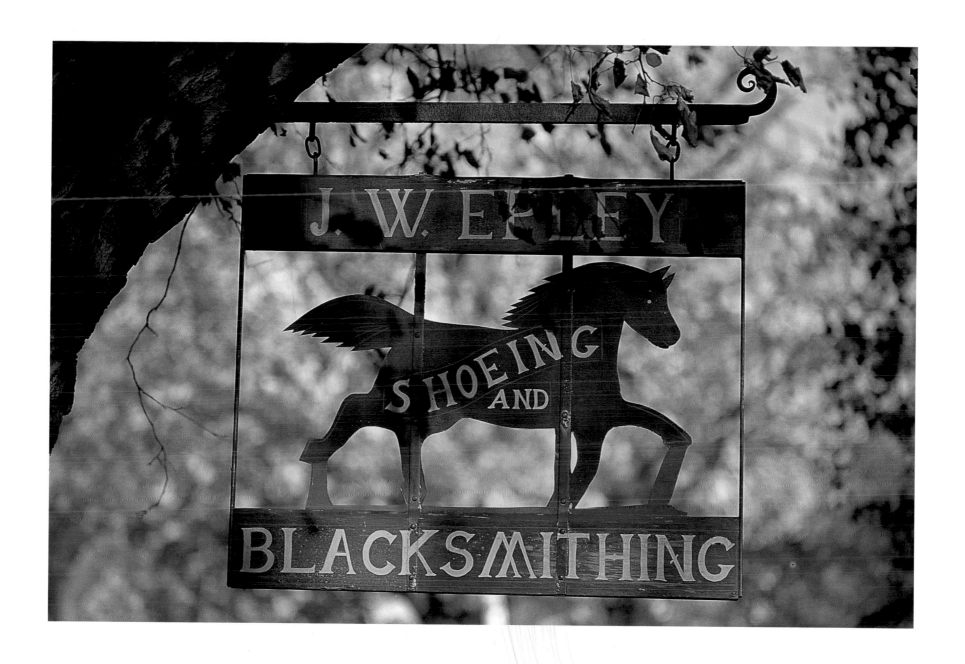

26. Solebury, Bucks County

27. Landis Valley Museum,
Lancaster County

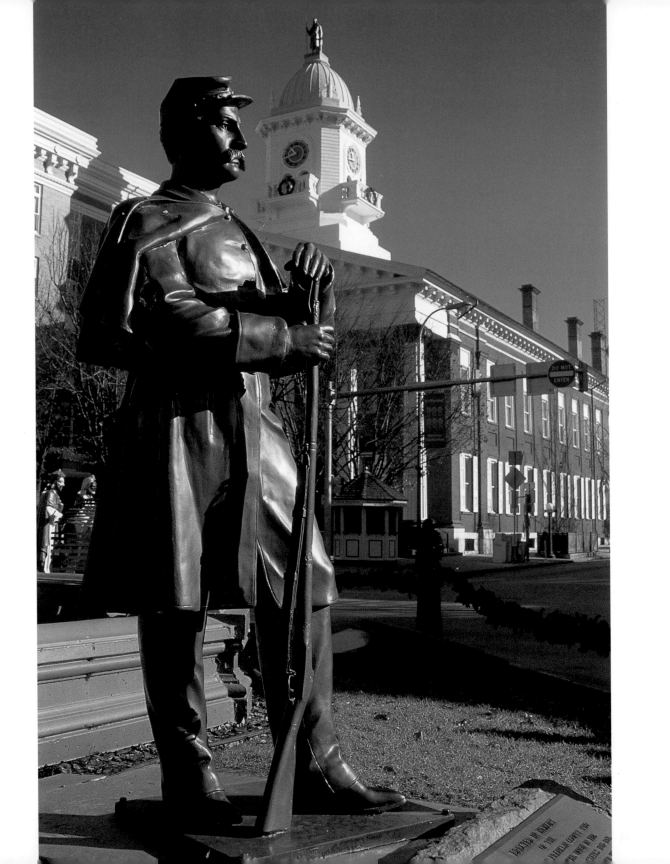

28. Memorial Square,
Chambersburg,
Franklin County

29. Pennsylvania statues

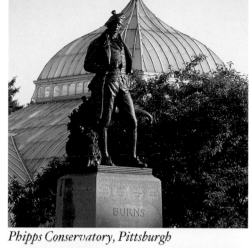

City Hall, Berwick

Phipps Conservatory, Pittsburgh

Italian Lake, Harrisburg

Capitol Complex, Harrisburg

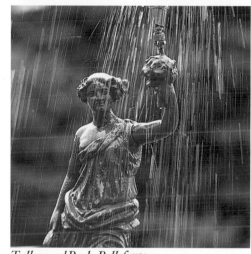

Talleyrand Park, Bellefonte

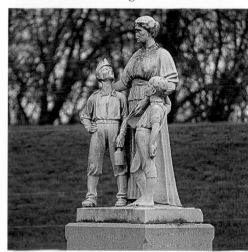

Nesbitt Park, Wilkes Barre

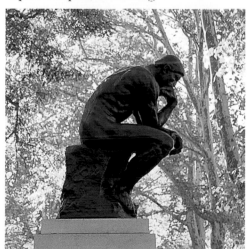

Rodin Museum, Philadelphia

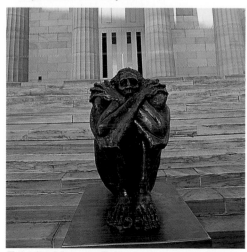

Erie Art Museum, Erie

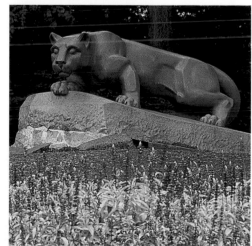

Nittany Lion Shrine, University Park

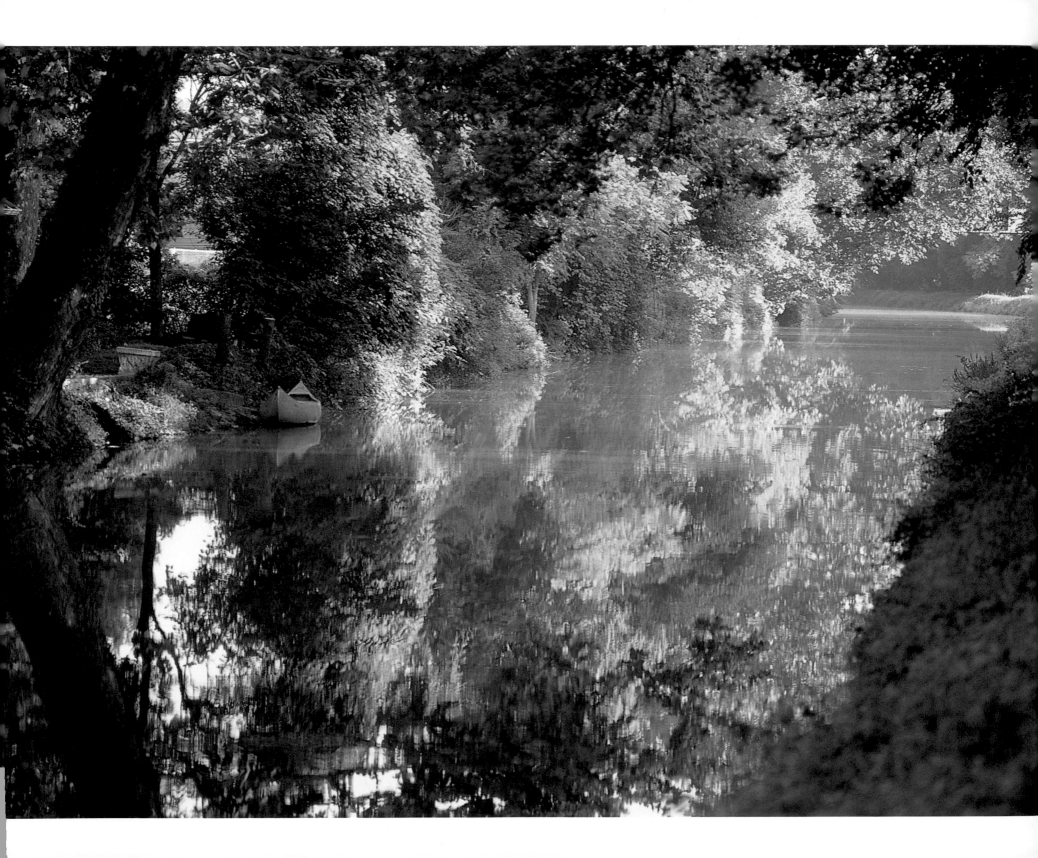

30. Delaware Canal State Park,
New Hope

31. National Canal Museum,
Hugh Moore Park, Easton

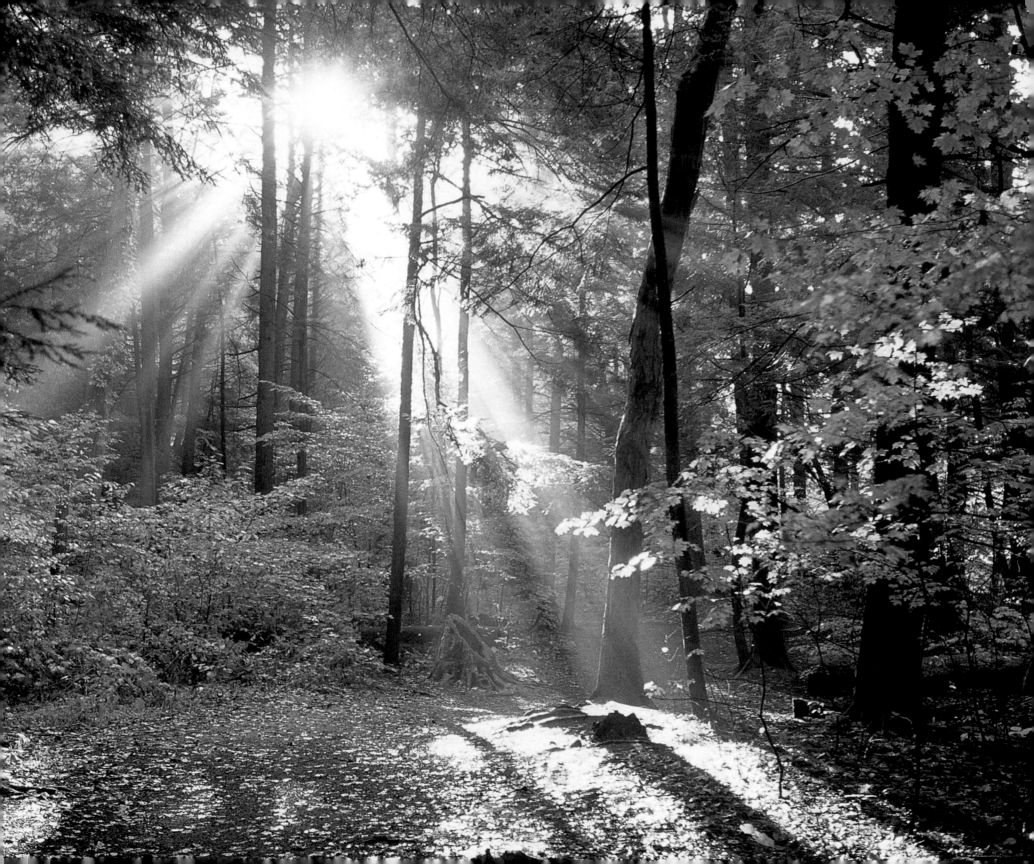

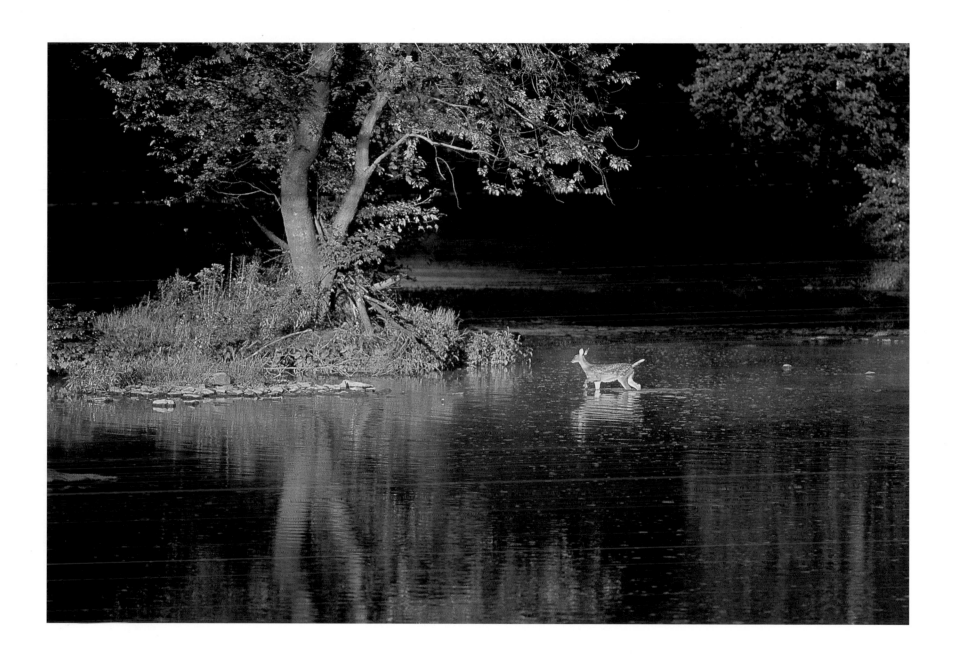

32. Dingmans Ferry,
Delaware Water Gap
National Recreation Area

33. Sherman's Creek,
Tyrone Township, Perry County

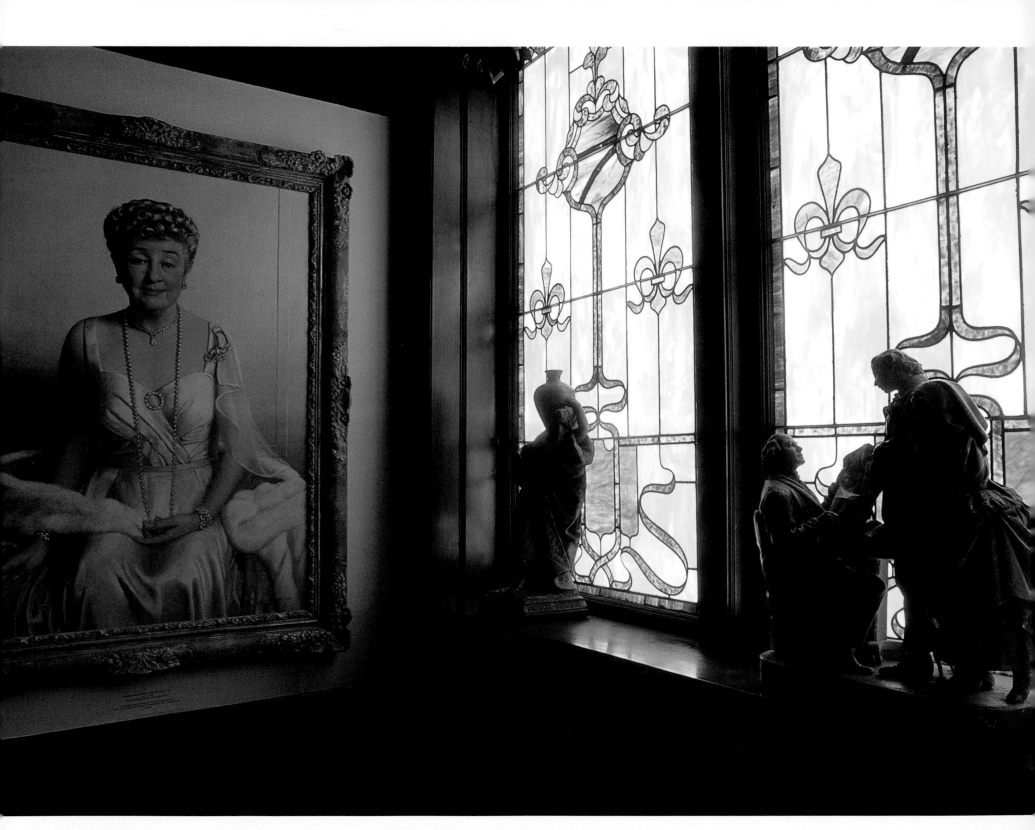

34. Caitlin House, Scranton

35. Bryn Athyn Cathedral,
Bryn Athyn

36-37. Pittsburgh skyline

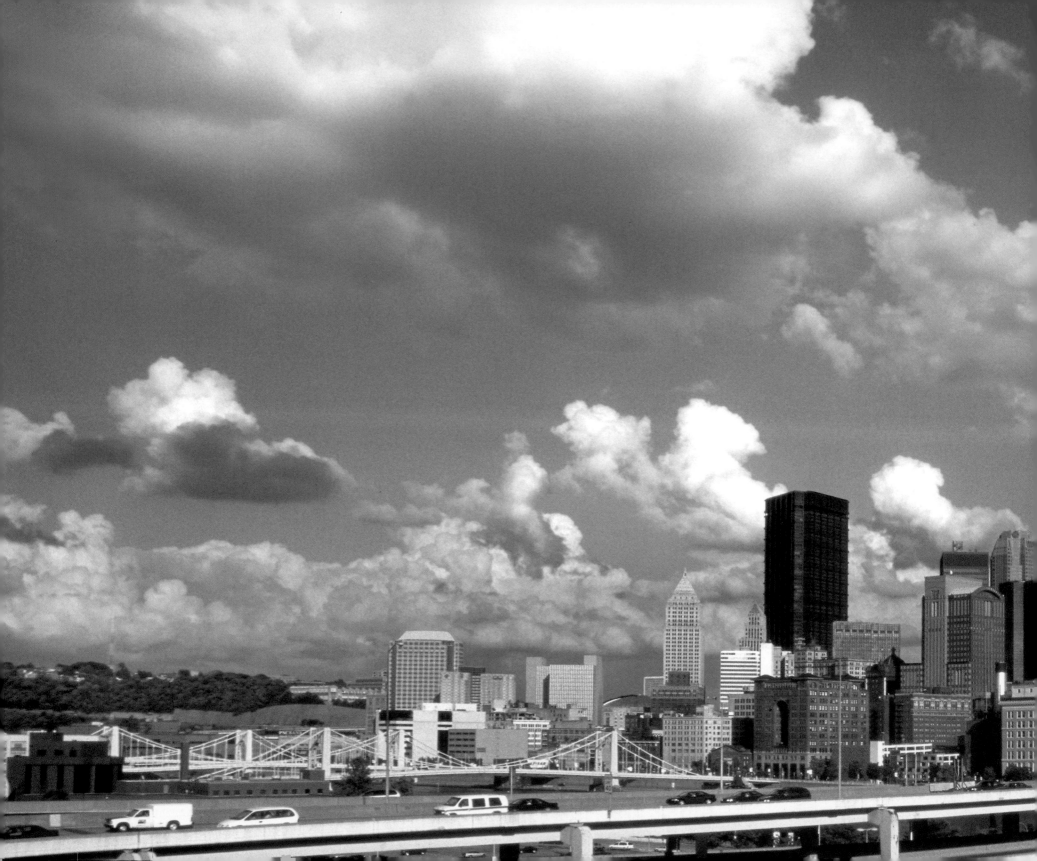

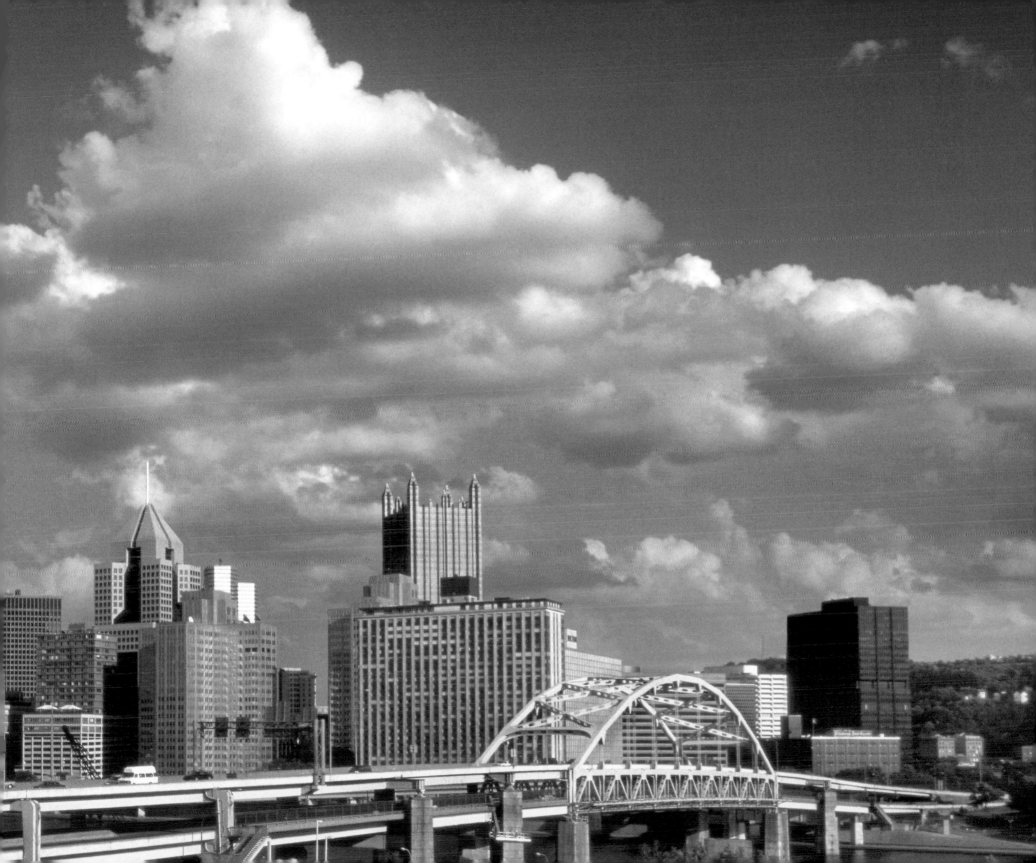

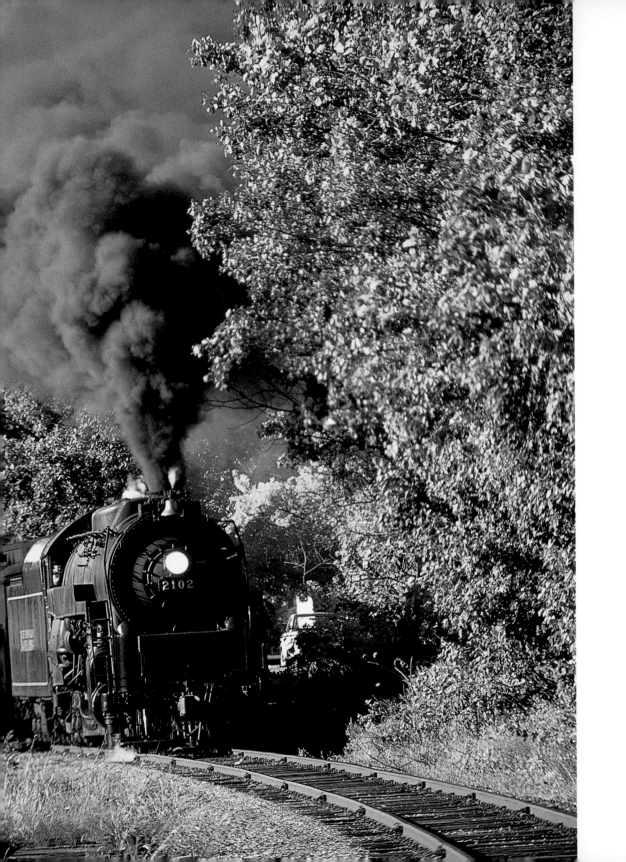

38. Blue Mountain & Northern Railroad,
Berks County

39. Thomas Newcomen
Library and Museum, Exton

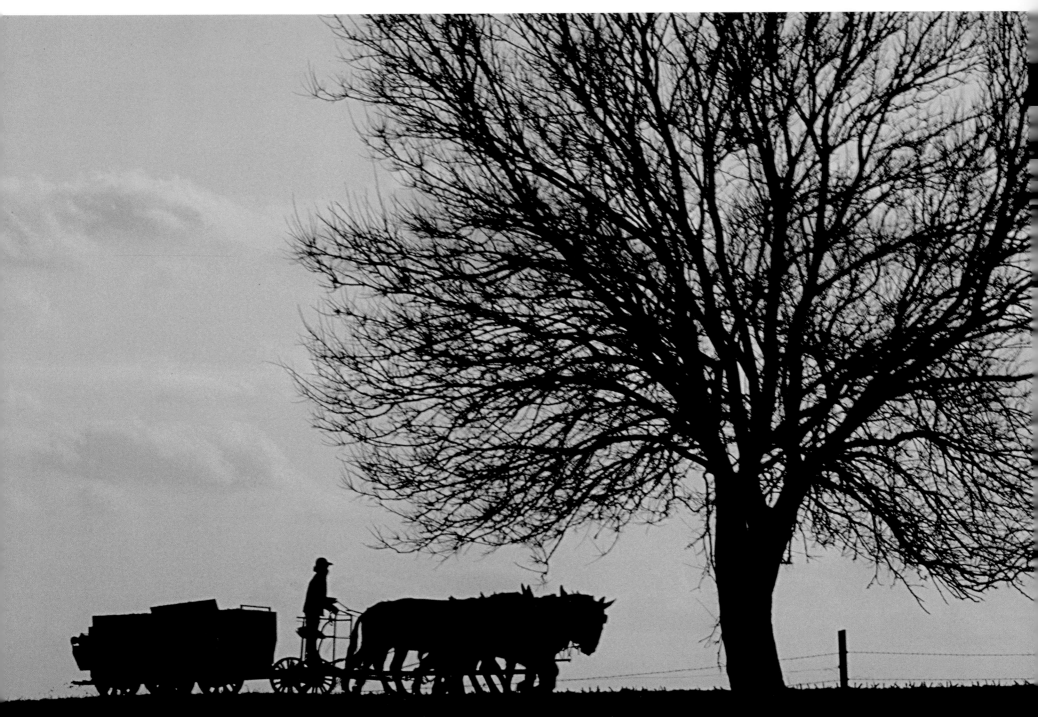

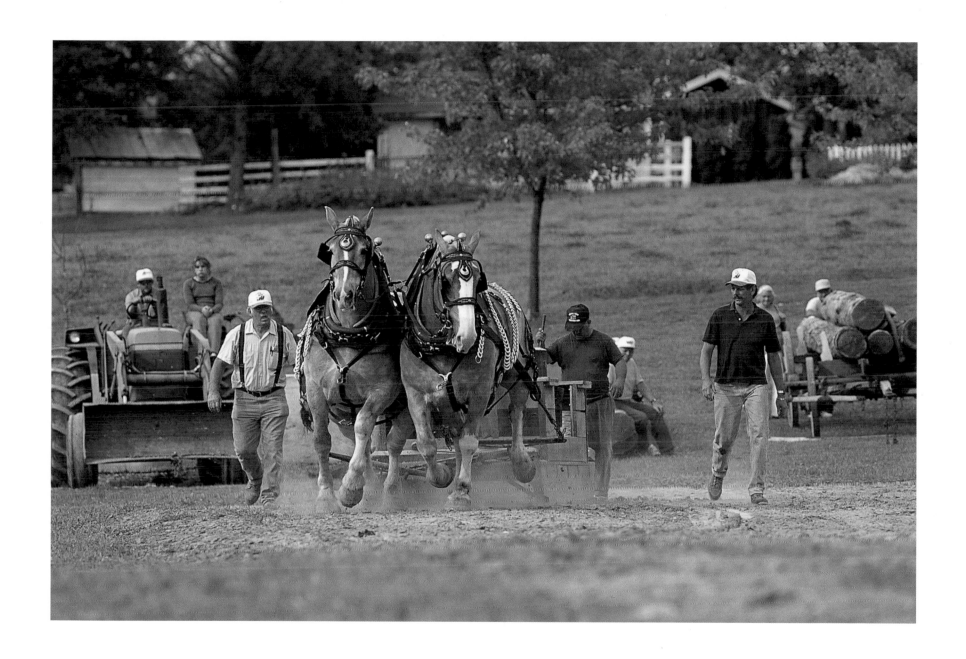

40. Amish farm,
Lancaster County

41. Historic Schaefferstown,
Lebanon County

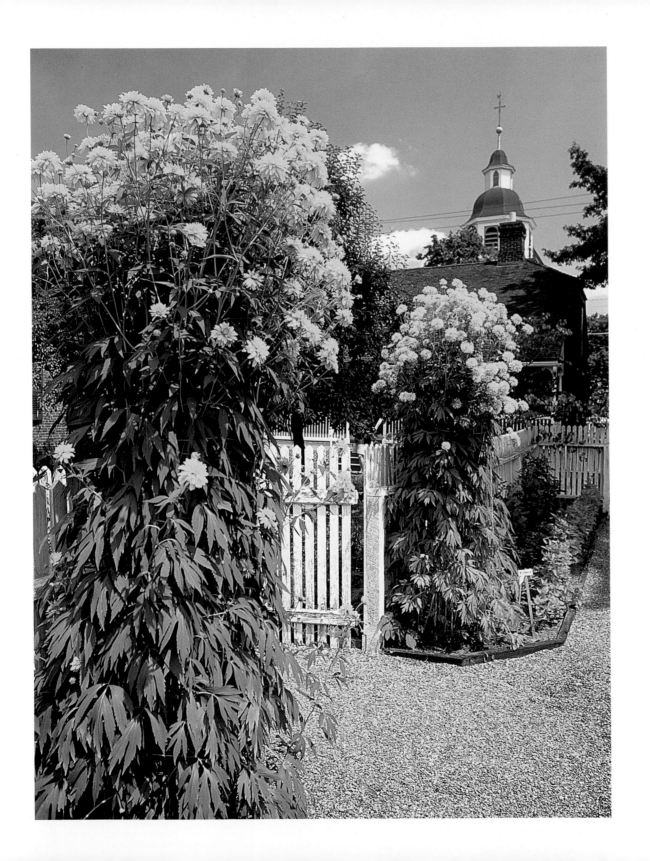

42. Old Economy Village,
Ambridge

43. Riverfront Park,
Harrisburg

Northumberland County Courthouse, Sunbury

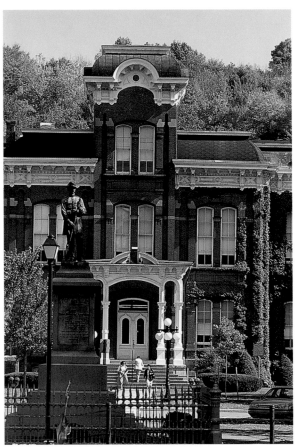

Wayne County Courthouse, Honesdale

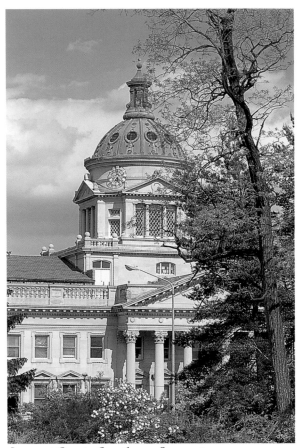

Somerset County Courthouse, Somerset

44. Pennsylvania courthouses

45. Luzerne County Courthouse,
Wilkes Barre

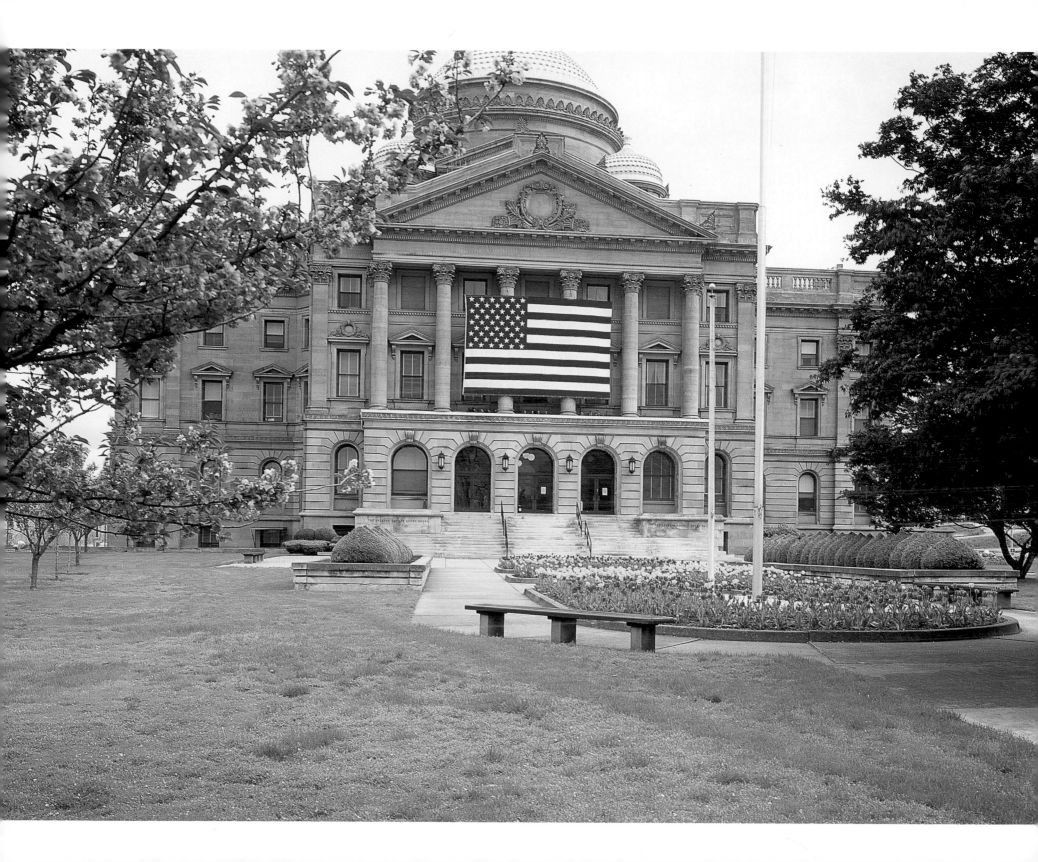

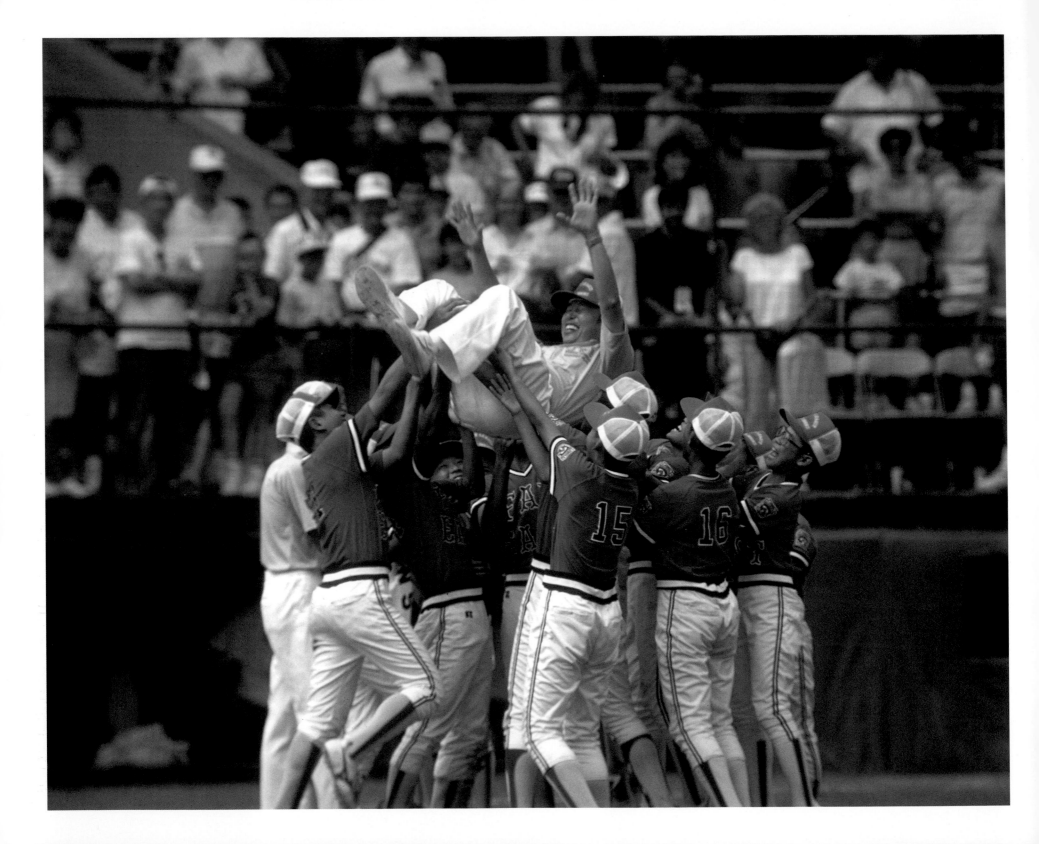

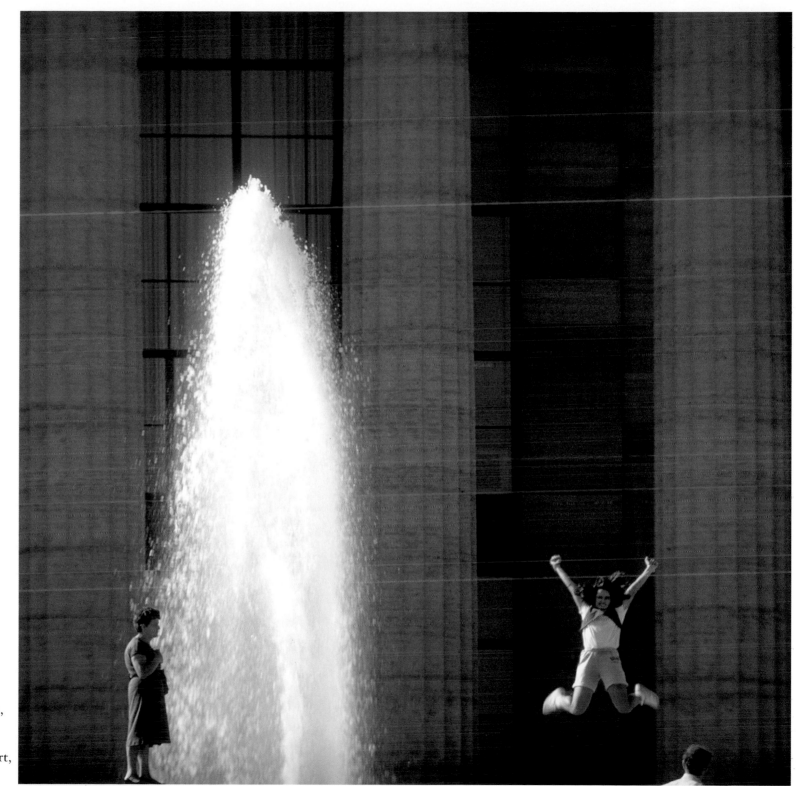

46. Little League World Series,
Williamsport

47. Philadelphia Museum of Art,
Philadelphia

48. Thomas Massey House, 1696,
Broomal, Delaware County

49. Sun Inn, 1760, Bethlehem

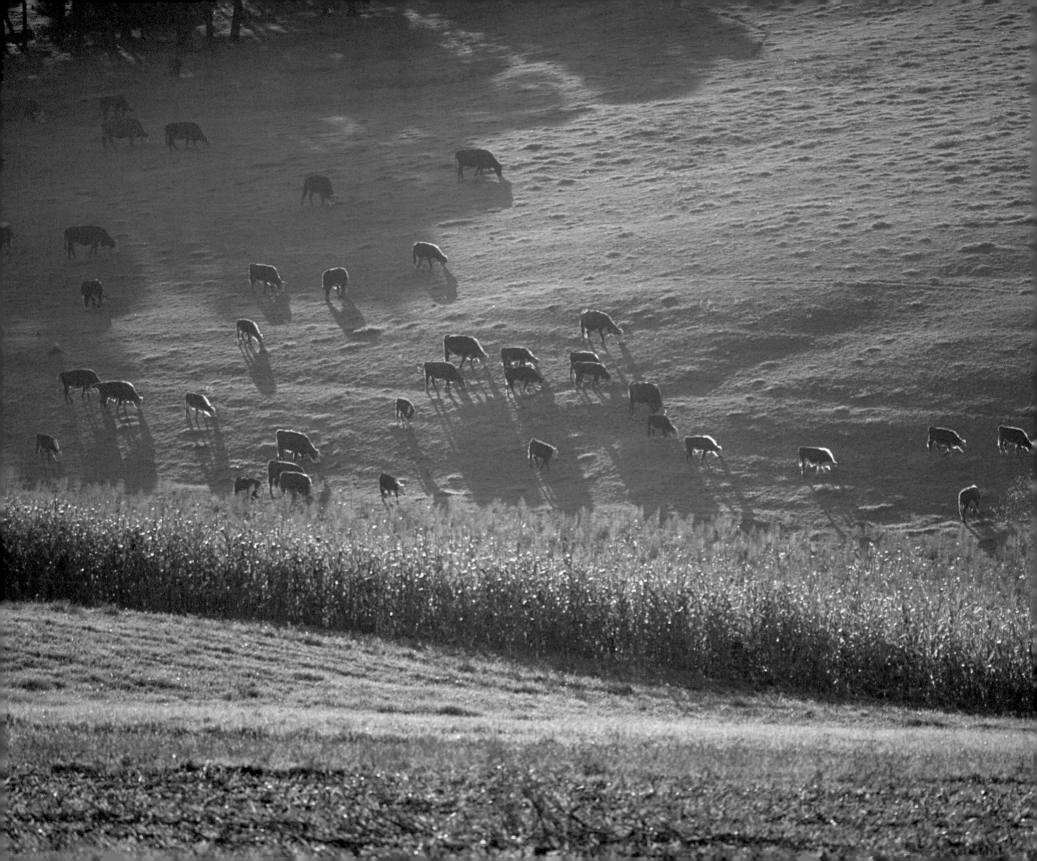

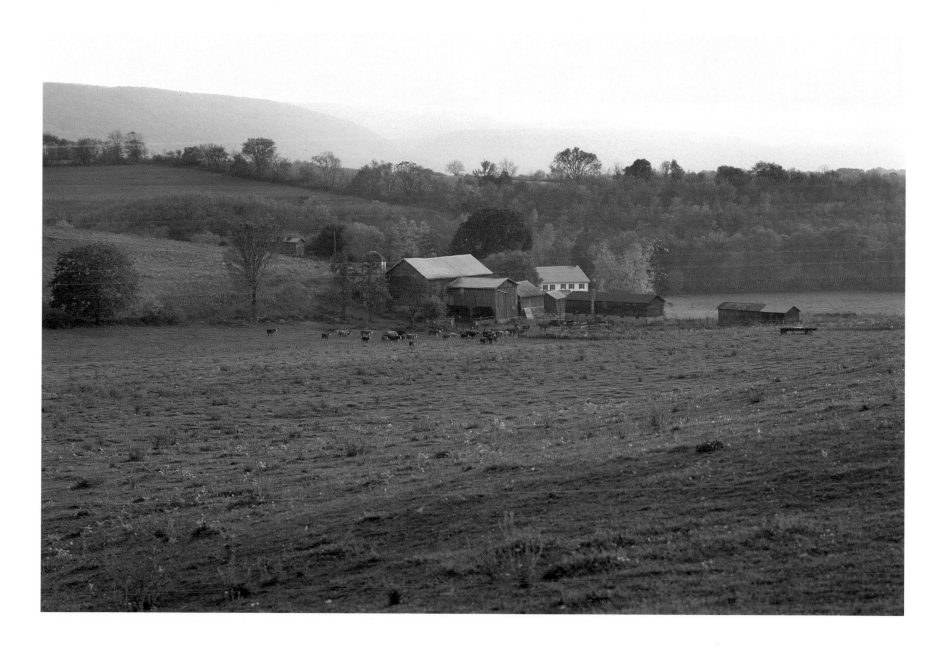

50. Greensburg, Westmoreland County

51. Boalsburg, Centre County

Bellefonte, Centre County

Reading, Berks County

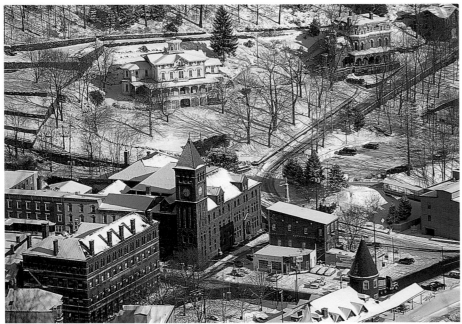

Jim Thorpe, Carbon County

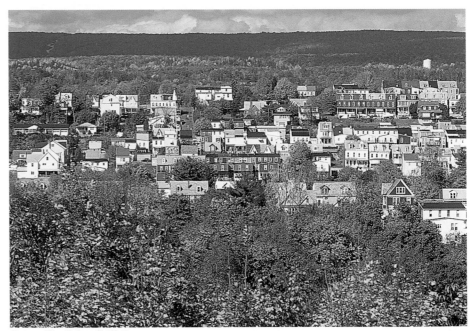

Pottsville, Schuylkill County

52. Roadside views
of Pennsylvania

53. Roadside America,
Shartlesville, Berks County

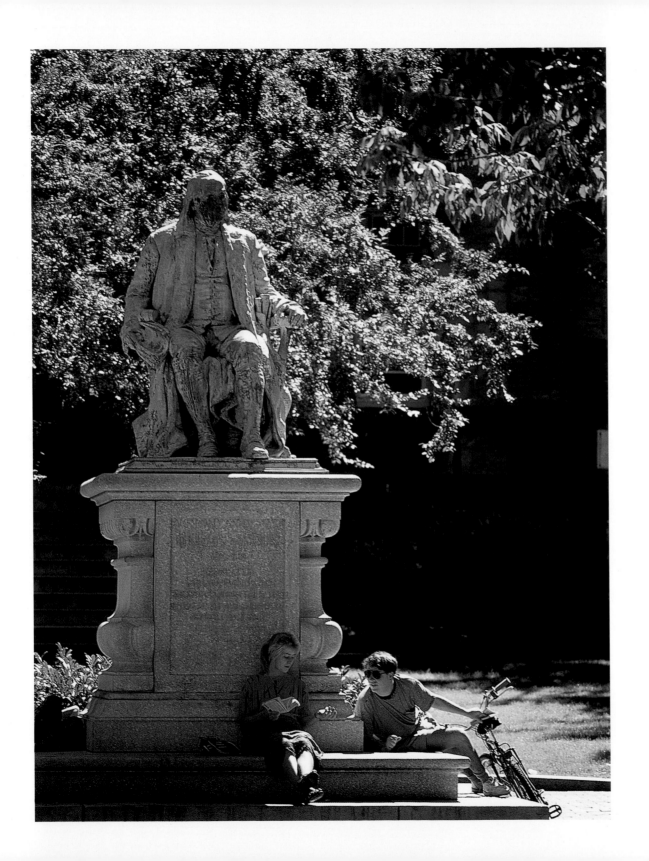

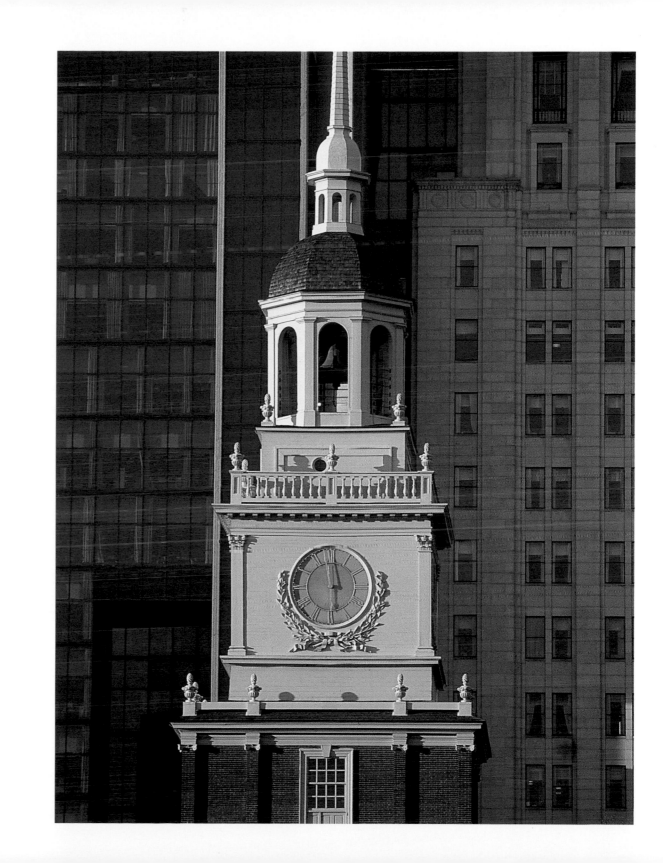

54. University of Pennsylvania,
Philadelphia

55. Independence Hall,
Independence National Historical Park,
Philadelphia

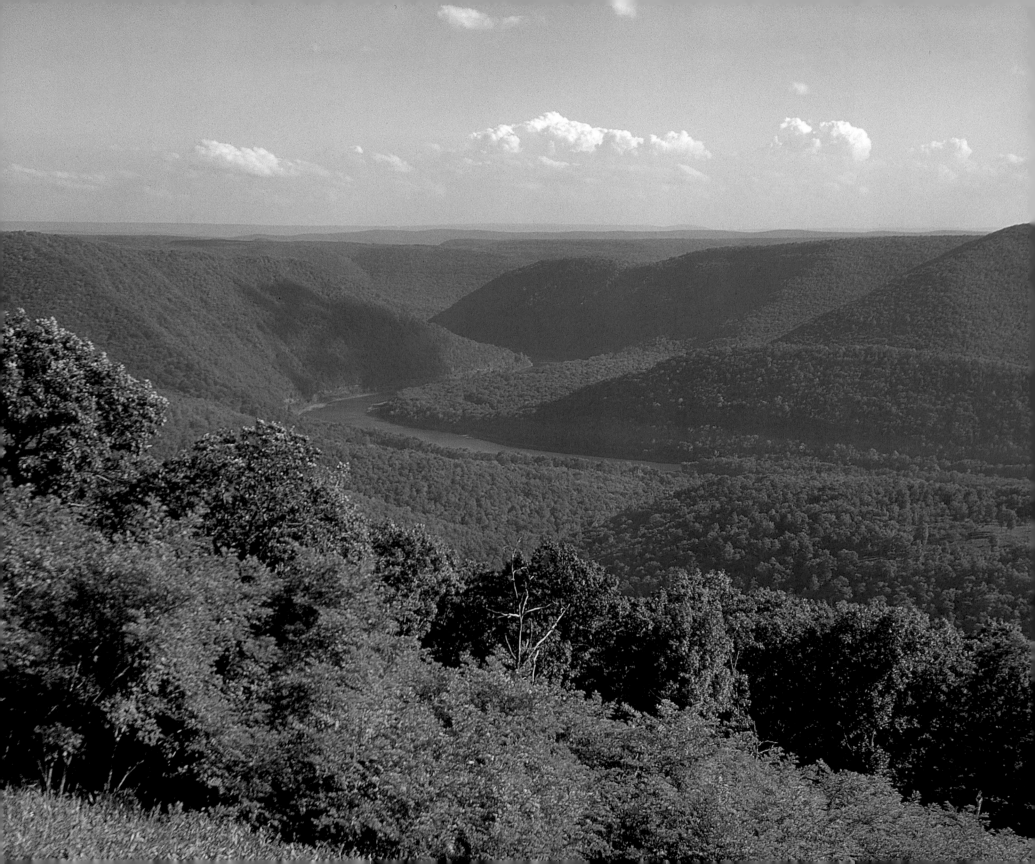

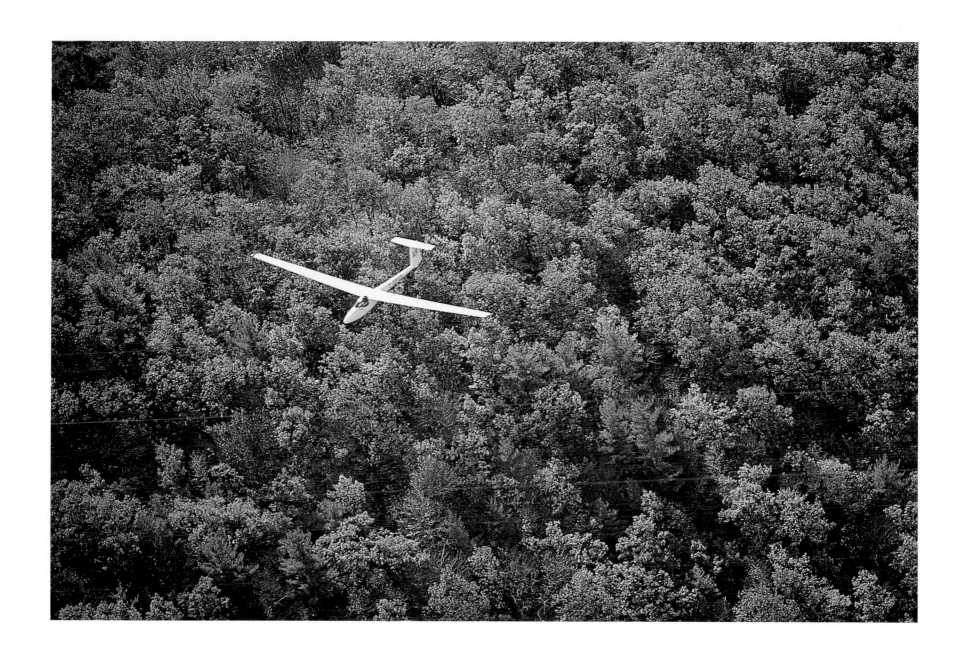

56. Hyner View State Park,
Clinton County

57. Glider, Bald Eagle Ridge,
Julian, Centre County

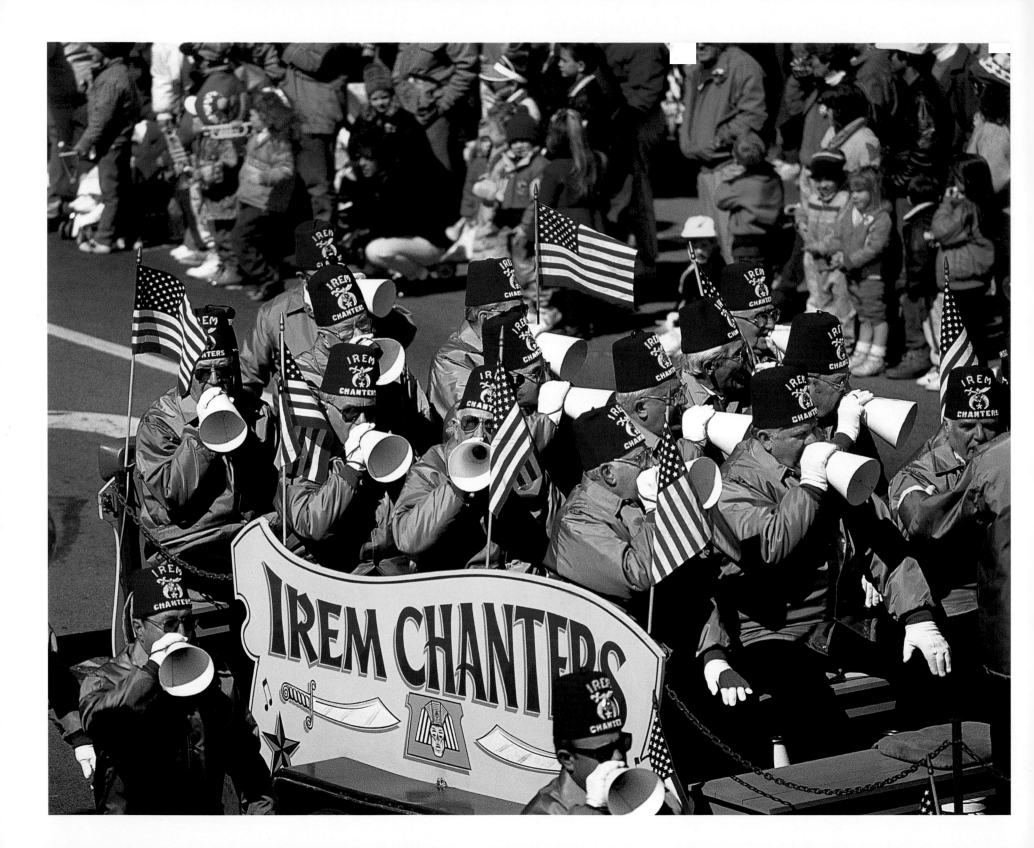

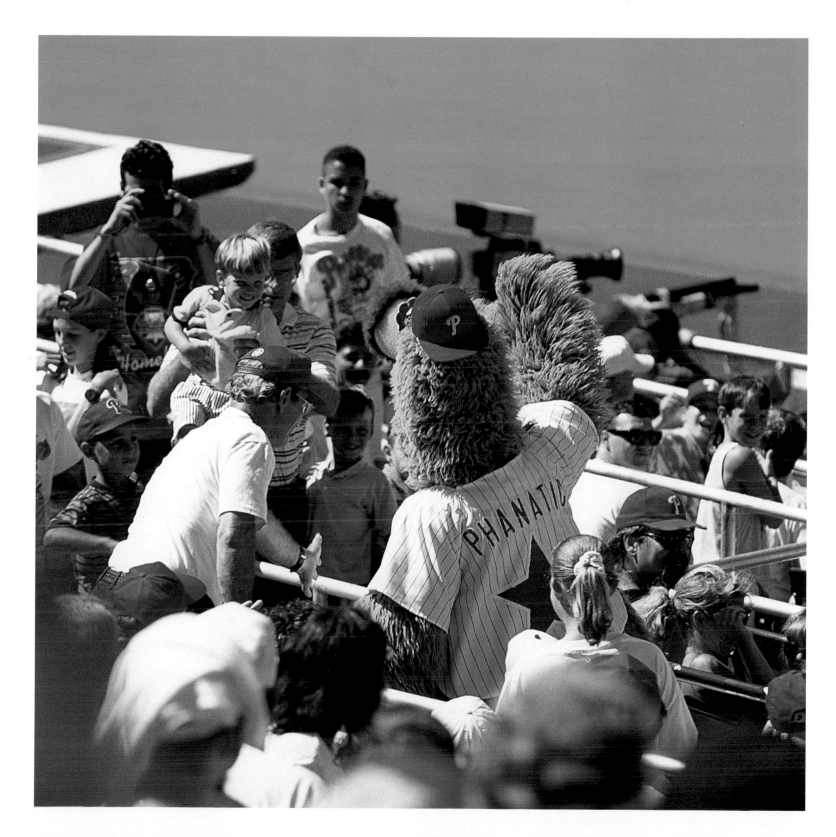

58. St. Patrick's Day Parade,
Scranton

59. Philly Phanatic,
Veterans Stadium,
Philadelphia

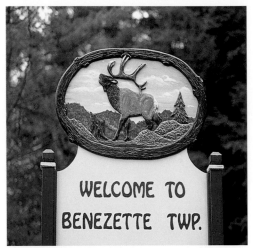

Benzette Township, Elk County

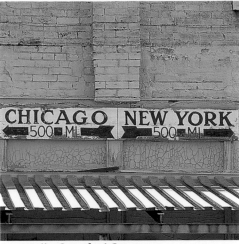

Linesville, Crawford County

Society Hill, Philadelphia

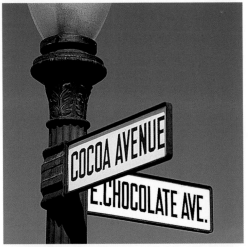

Hershey, Dauphin County

Portersville, Lawrence County

Jim Thorpe, Carbon County

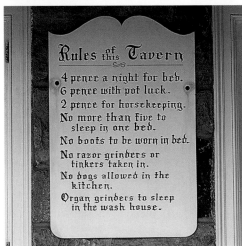

Slippery Rock, Butler County

Titusville, Venango County

Newtown, Bucks County

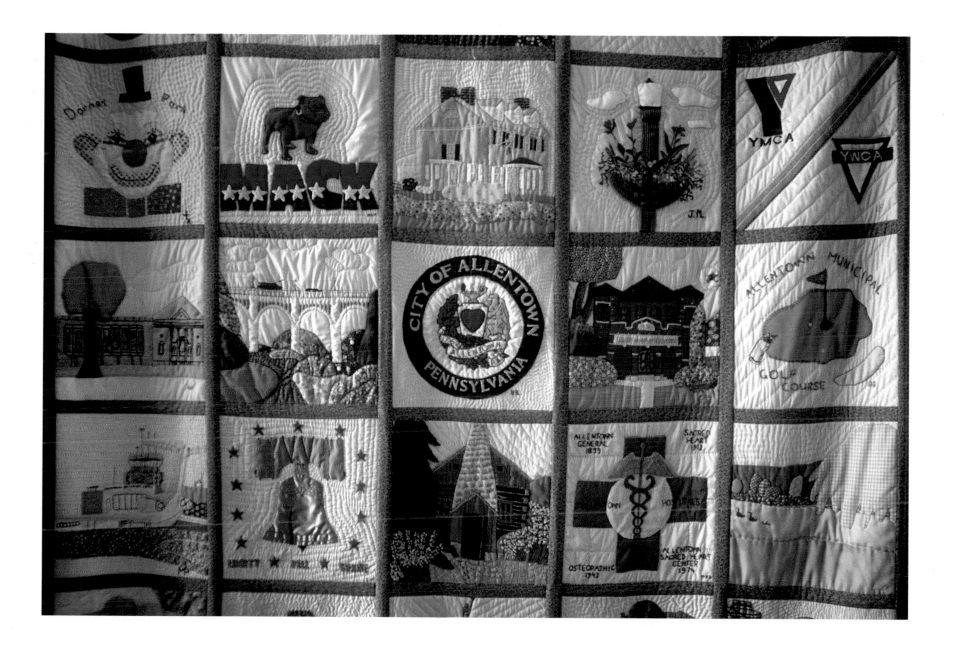

60. Signs of Pennsylvania

61. Quilt, Allentown Art Museum, Allentown

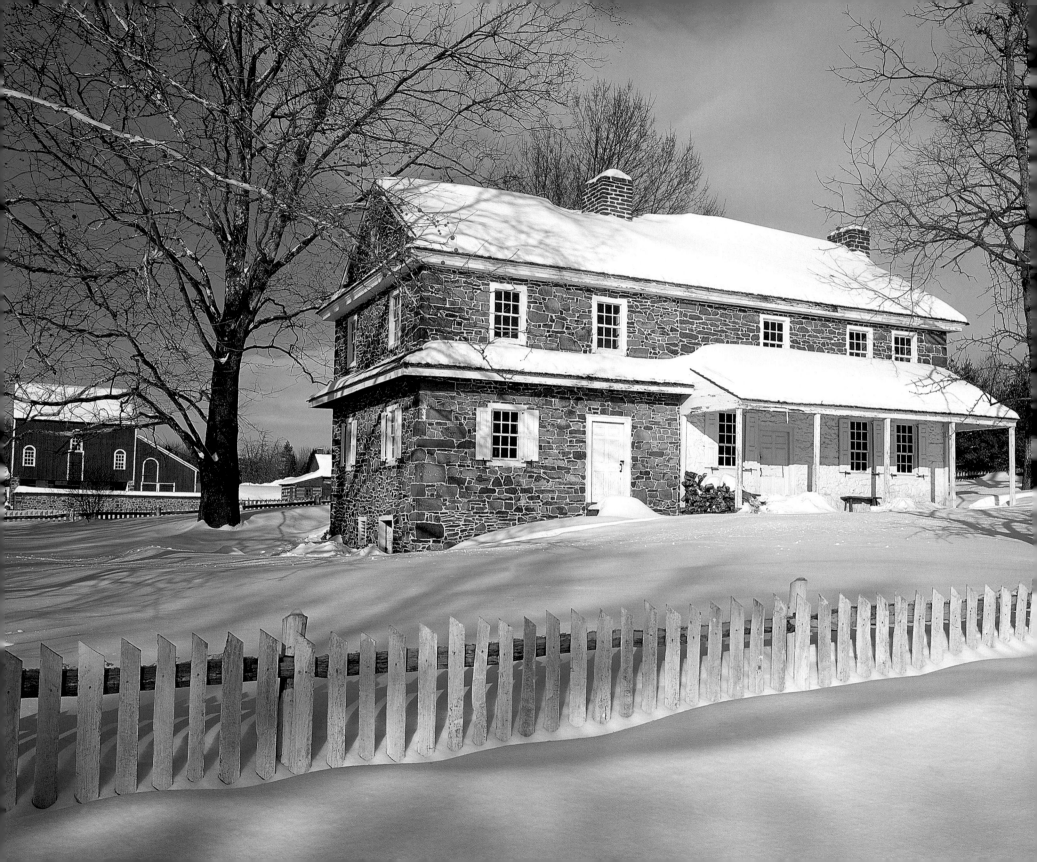

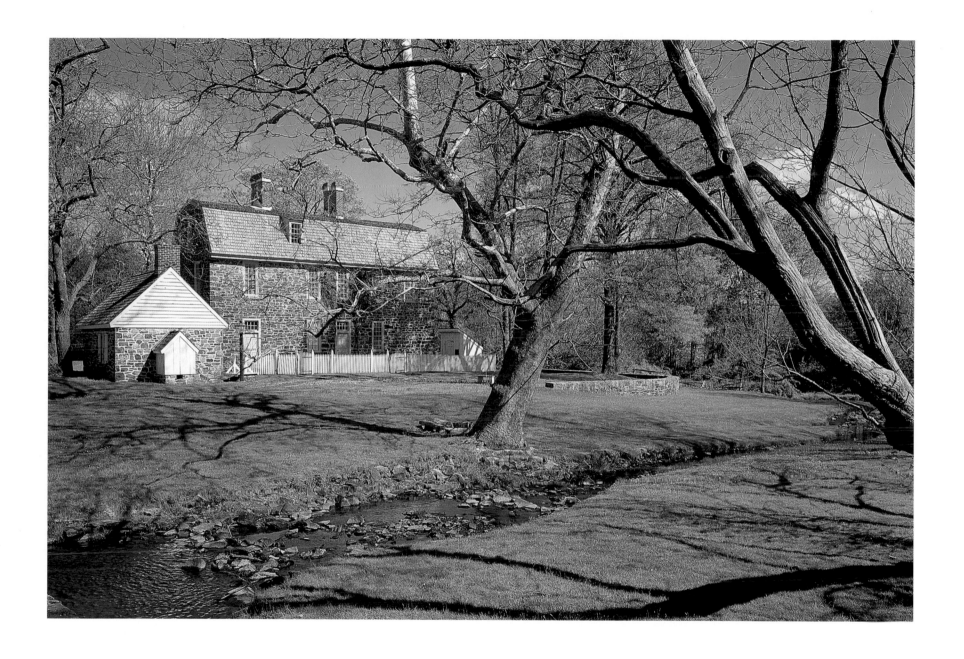

62. Daniel Boone Homestead,
Birdsboro

63. Keith House, Graeme Park, Horsham

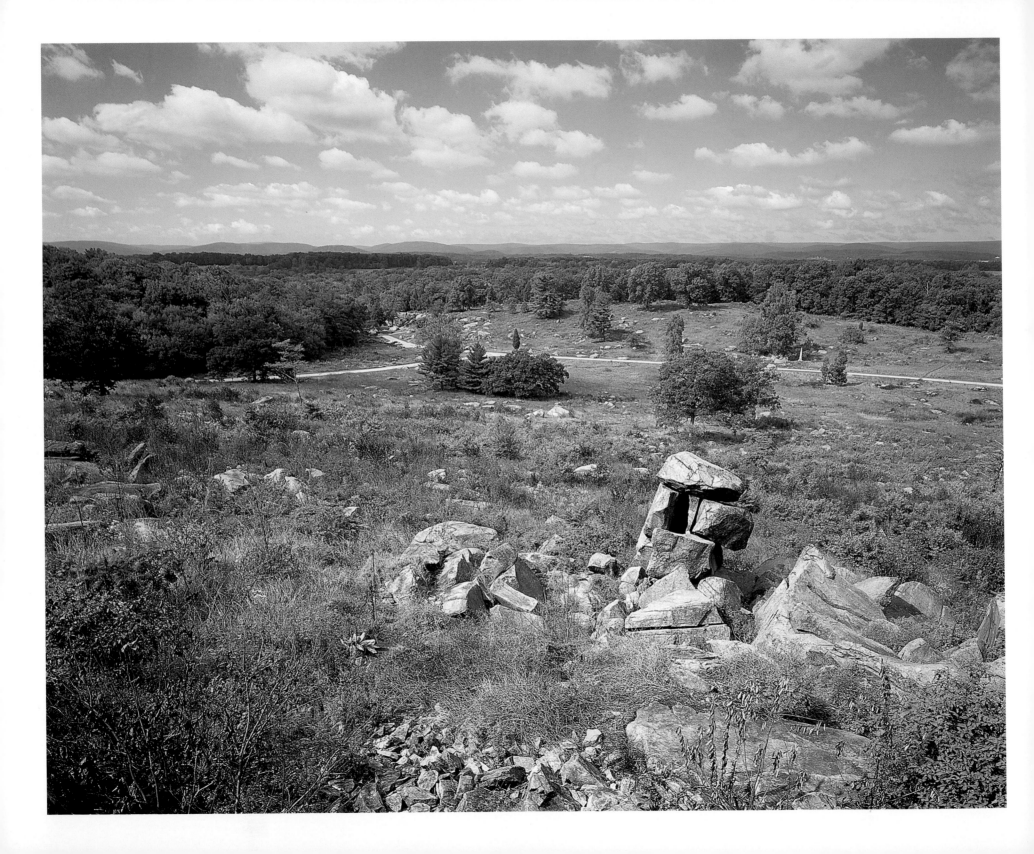

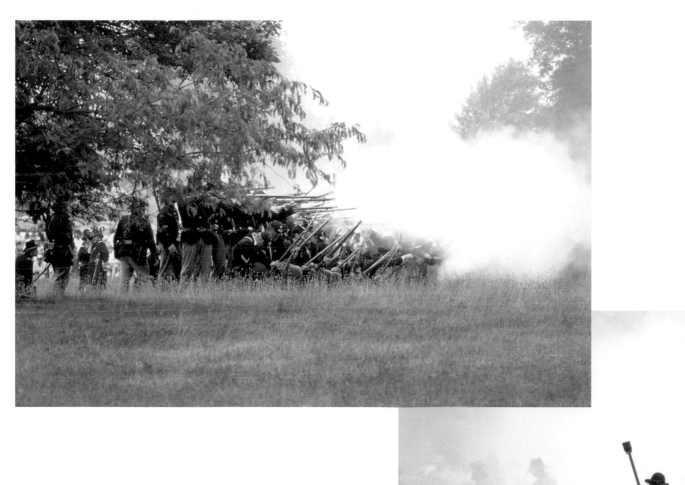

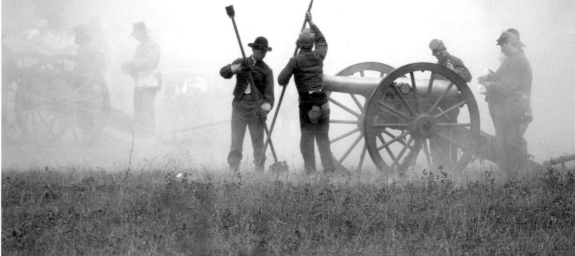

64. Little Round Top,
Gettysburg National Military Park

65. Battle of Gettysburg reenactment

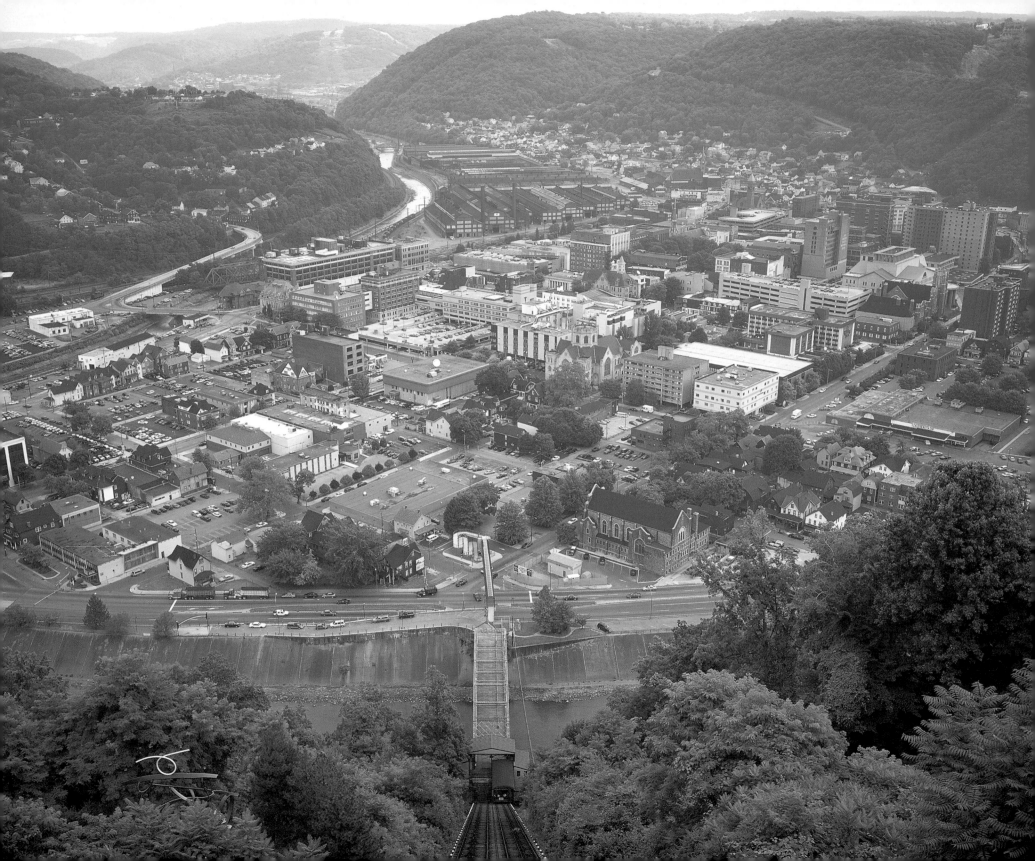

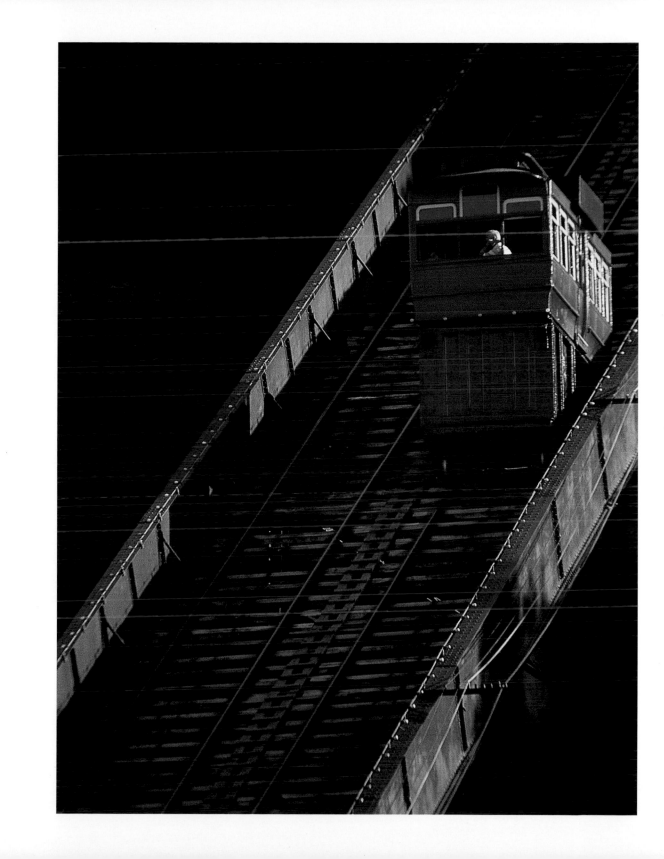

66. Johnstown, view from incline

67. Duquesne Incline,
Pittsburgh

68-69. Cumberland Valley,
North Middleton, Cumberland County

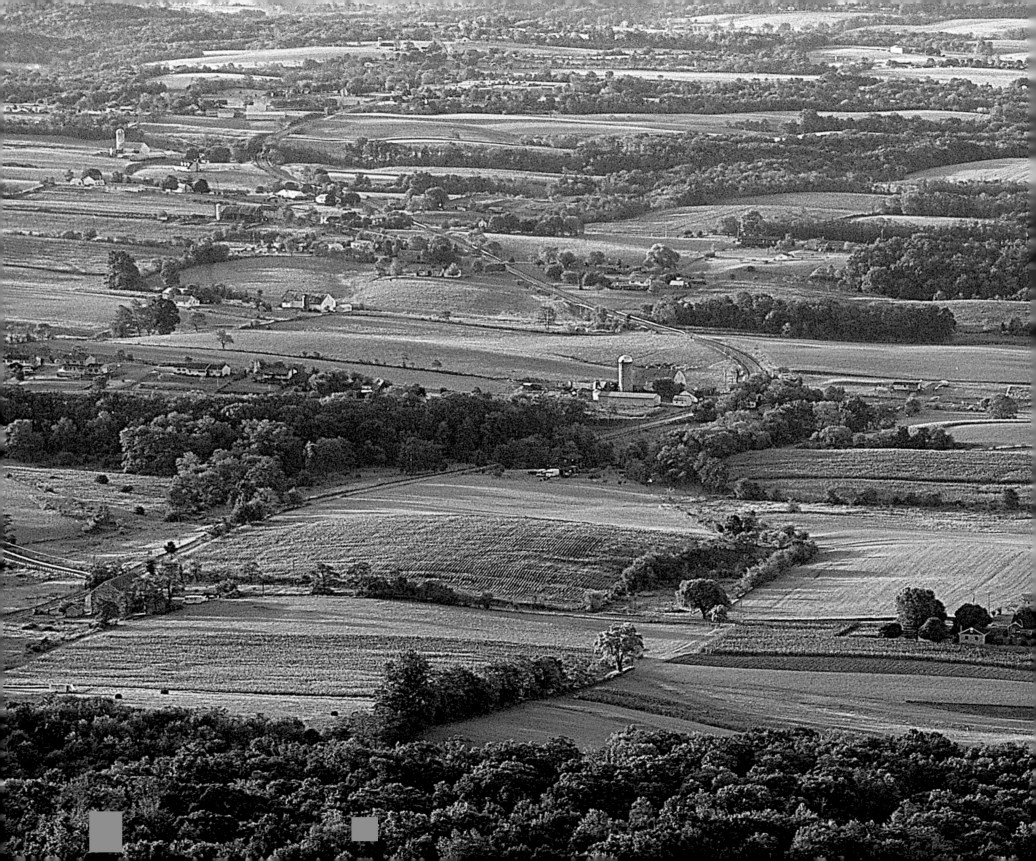

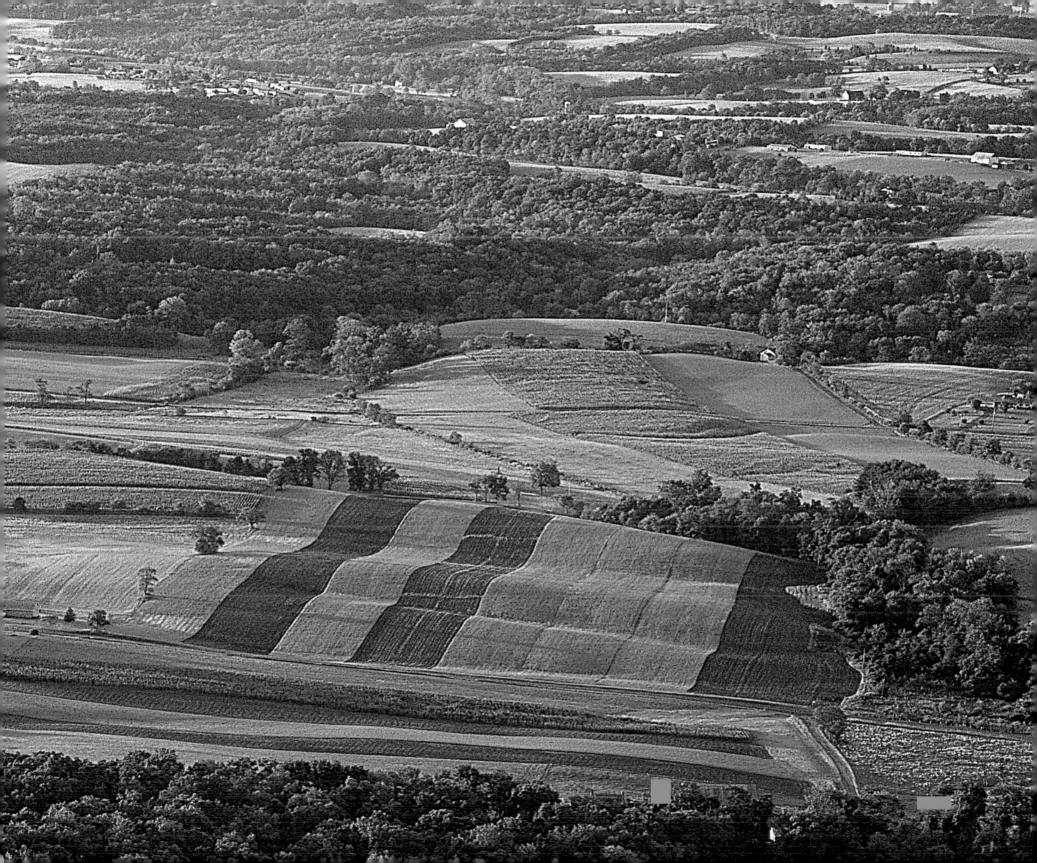

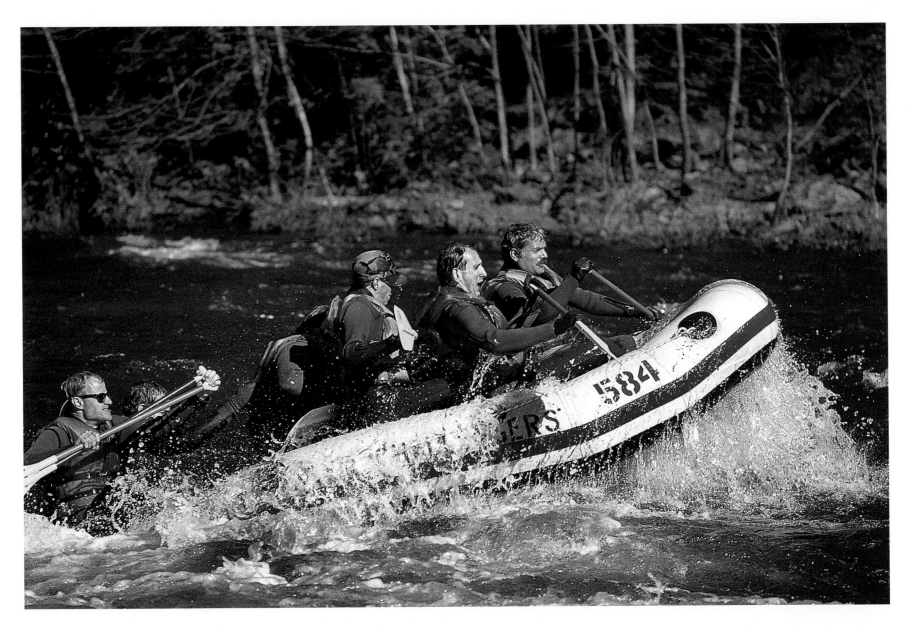

70. Lehigh Gorge State Park,
White Haven

71. Washington Crossing,
Bucks County

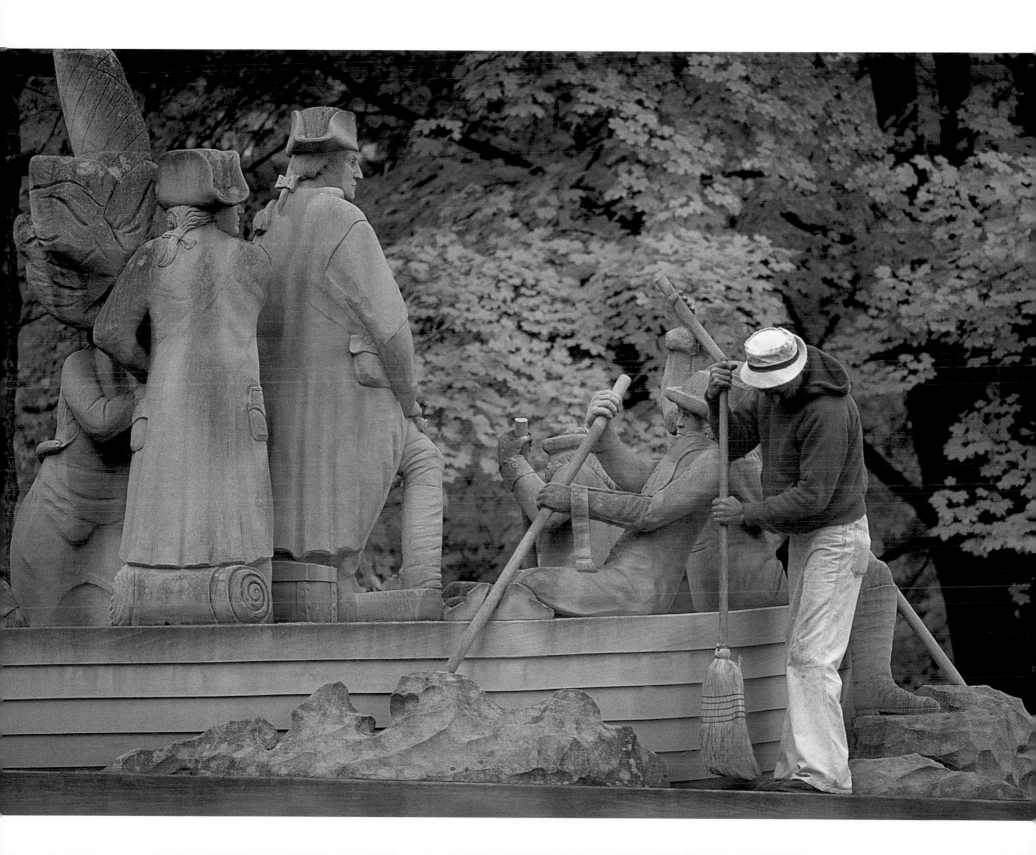

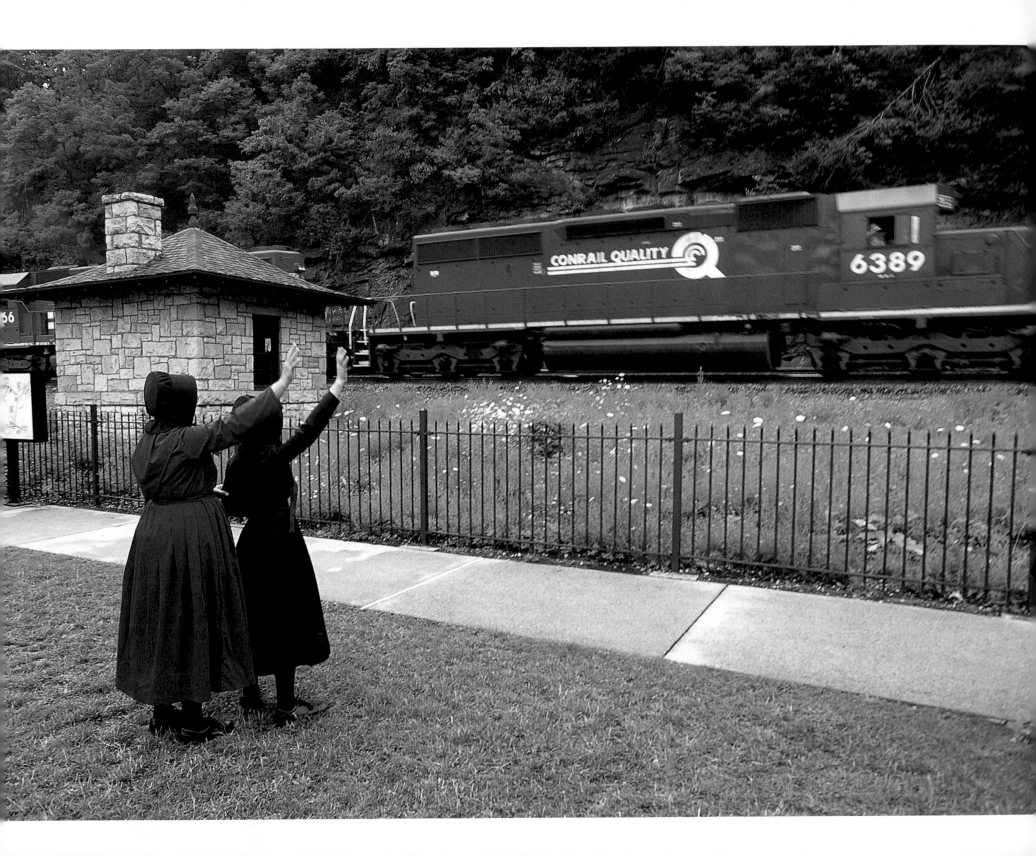

72. Horseshoe Curve
National Historic Landmark, Altoona

73. Train yard, Jim Thorpe, Carbon County

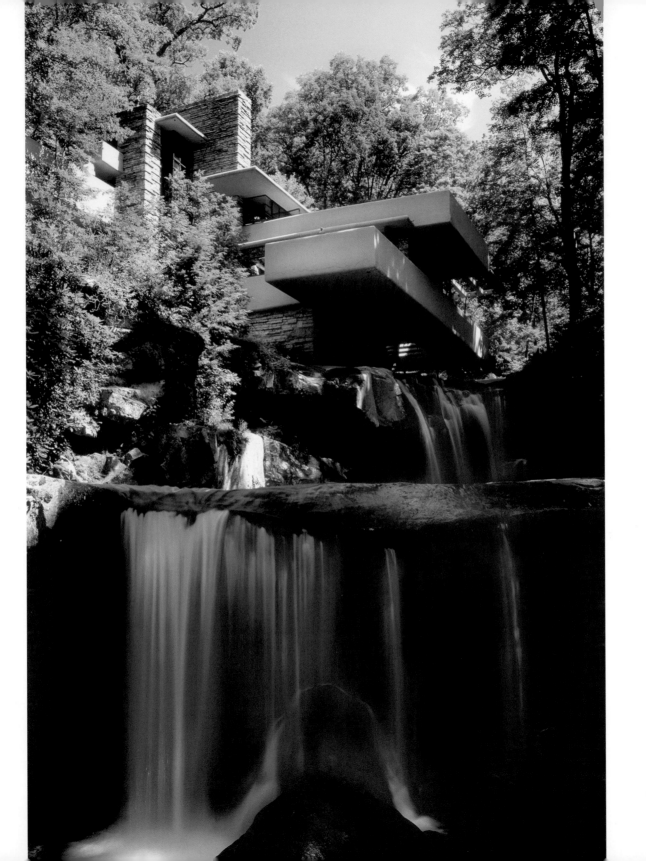

74. Fallingwater,
Mill Run, Fayette County

75. Harrison Wright Falls,
Ricketts Glen State Park

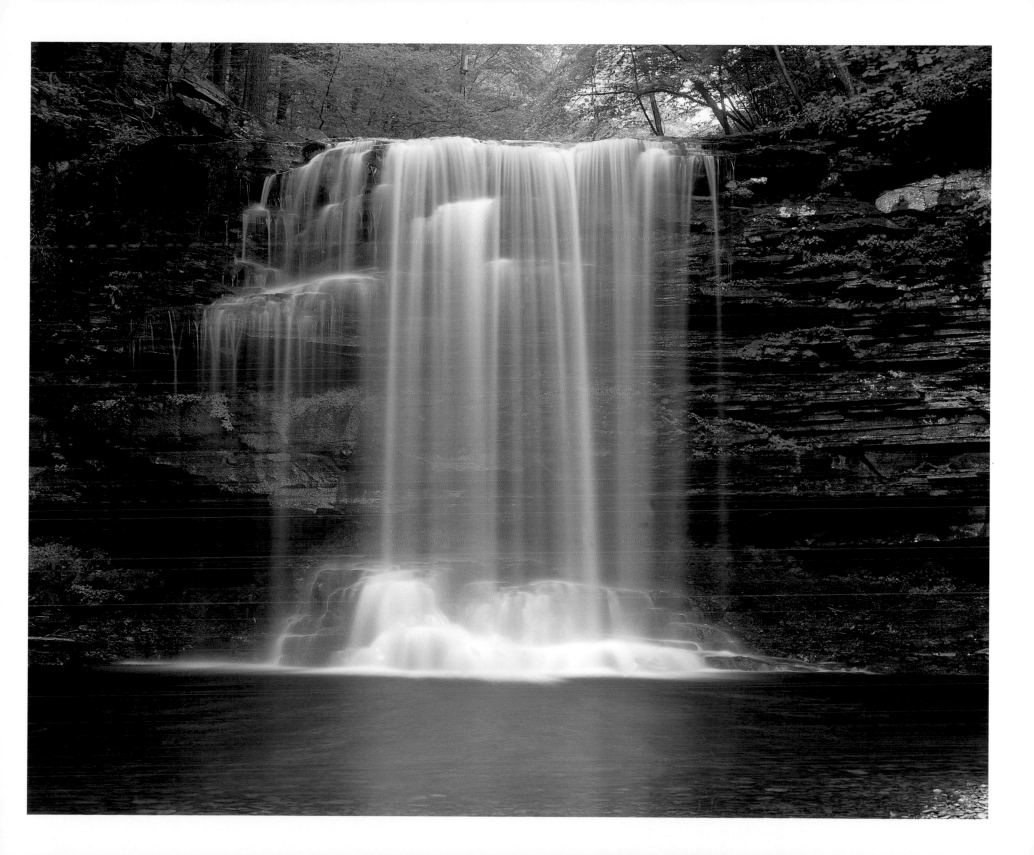

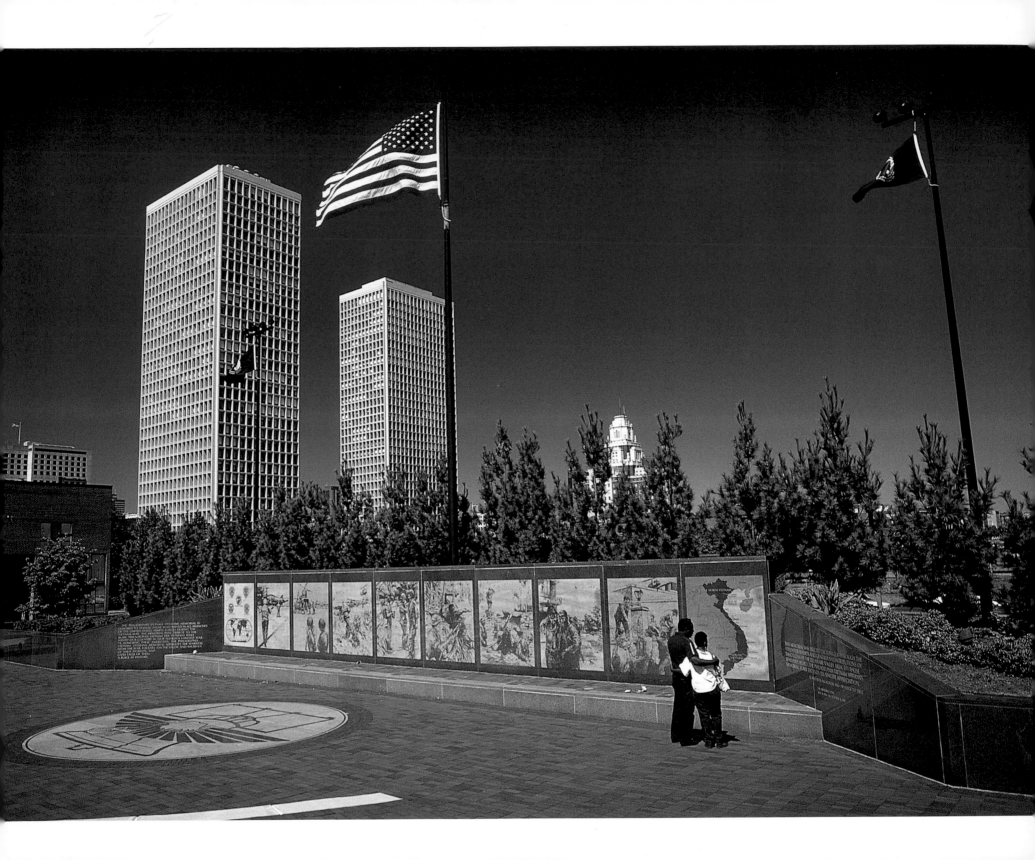

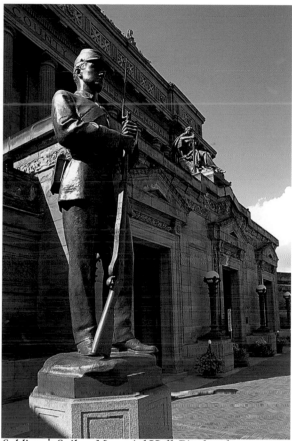

Soldiers & Sailors Memorial Hall, Pittsburgh

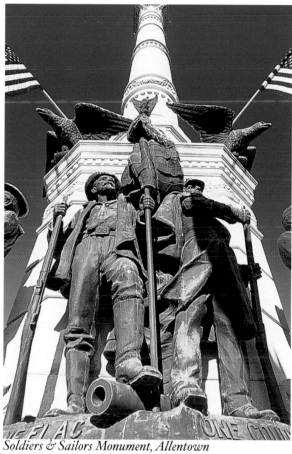

Soldiers & Sailors Monument, Allentown

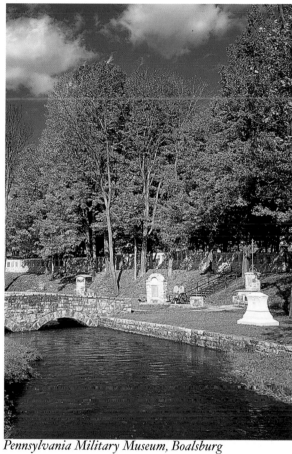

Pennsylvania Military Museum, Boalsburg

76. The Vietnam Veterans Memorial,
Philadelphia

77. Pennsylvania war memorials

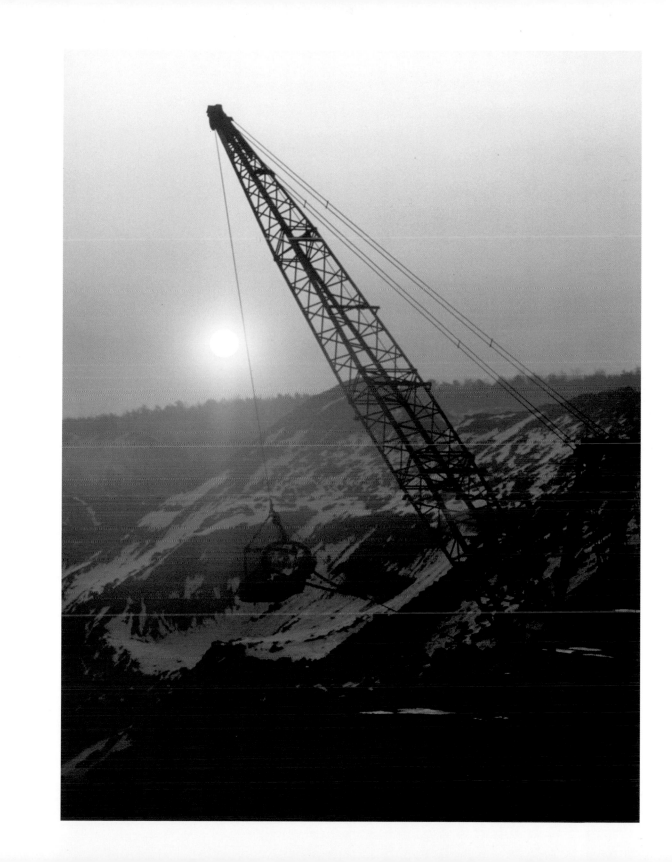

78. Sharpe House,
Eckley Miners' Village, Carbon County

79. Anthracite coal mining near
Hazleton, Luzerne County

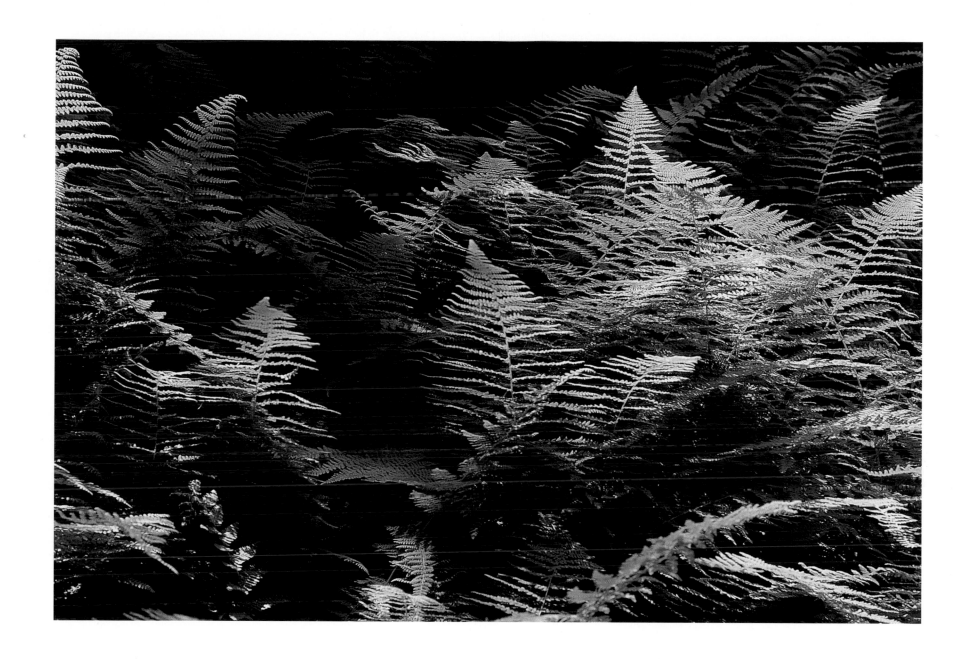

80. Sproul State Forest,
Clinton County

81. Hickory Run State Park,
Carbon County

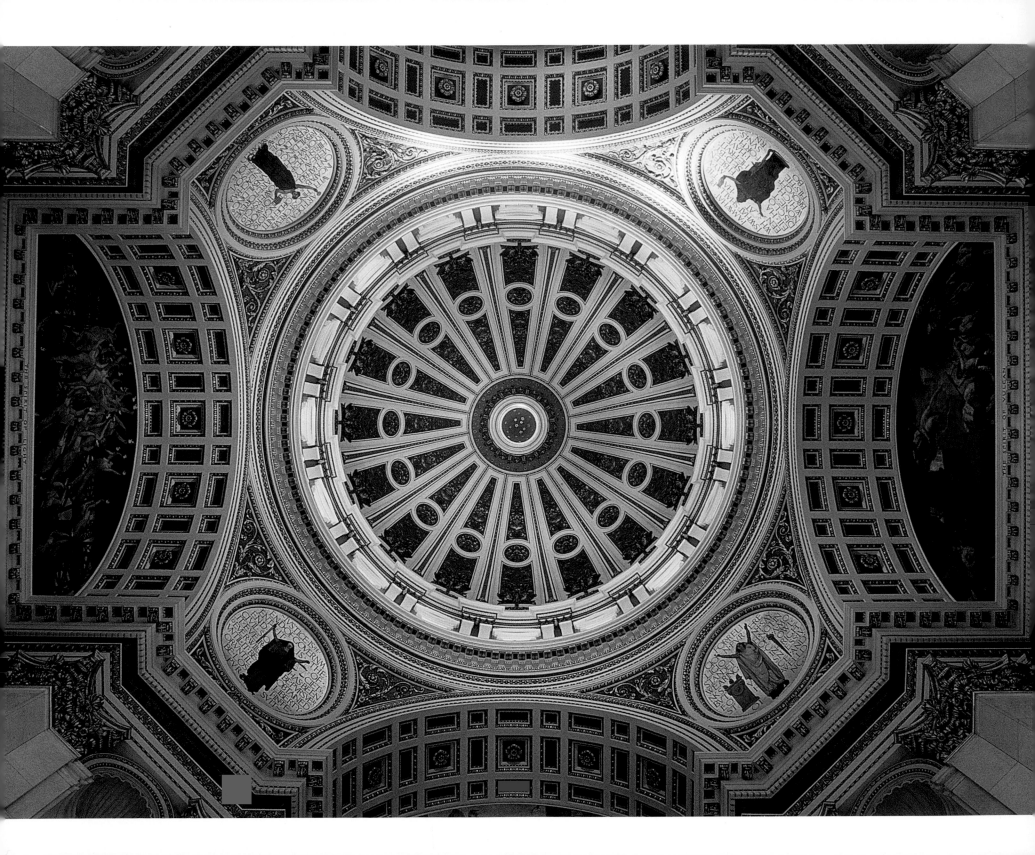

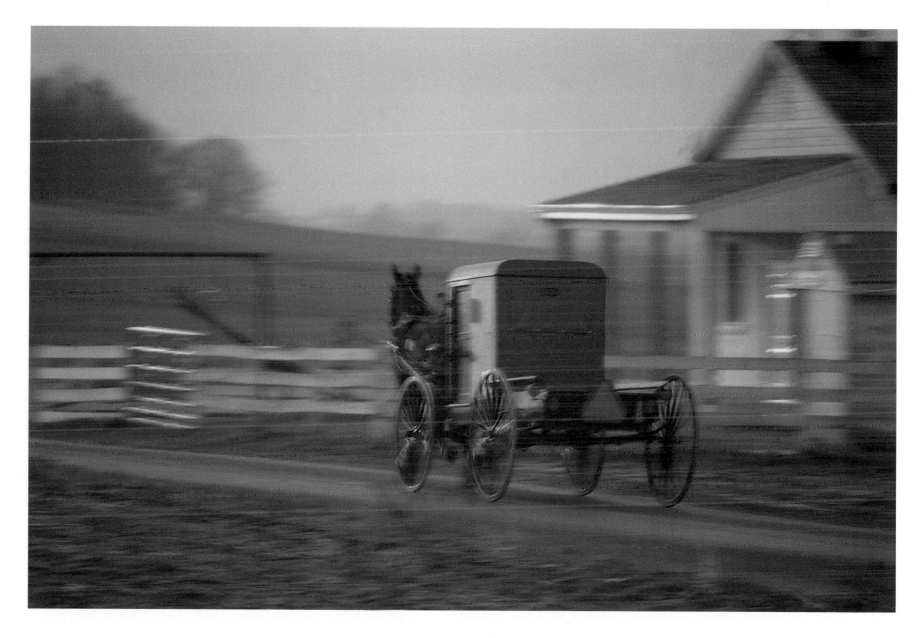

82. Capitol Rotunda, Harrisburg

83. Amish horse and buggy,
Lancaster County

Penn State Trial Gardens, University Park

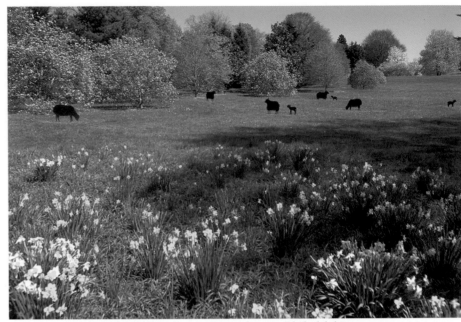

Morris Arboretum of the University of Pennsylvania, Philadelphia

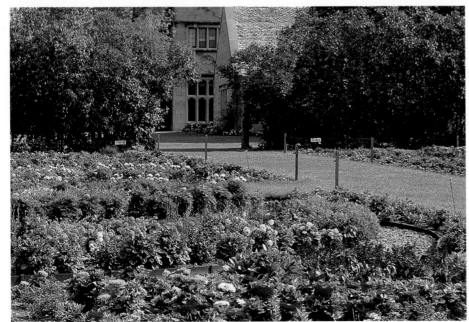

Hartwood Acres, Pittsburgh

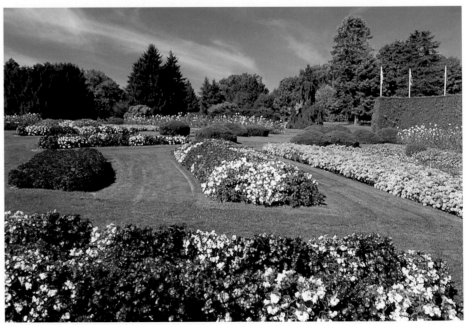

Hershey Gardens, Hershey

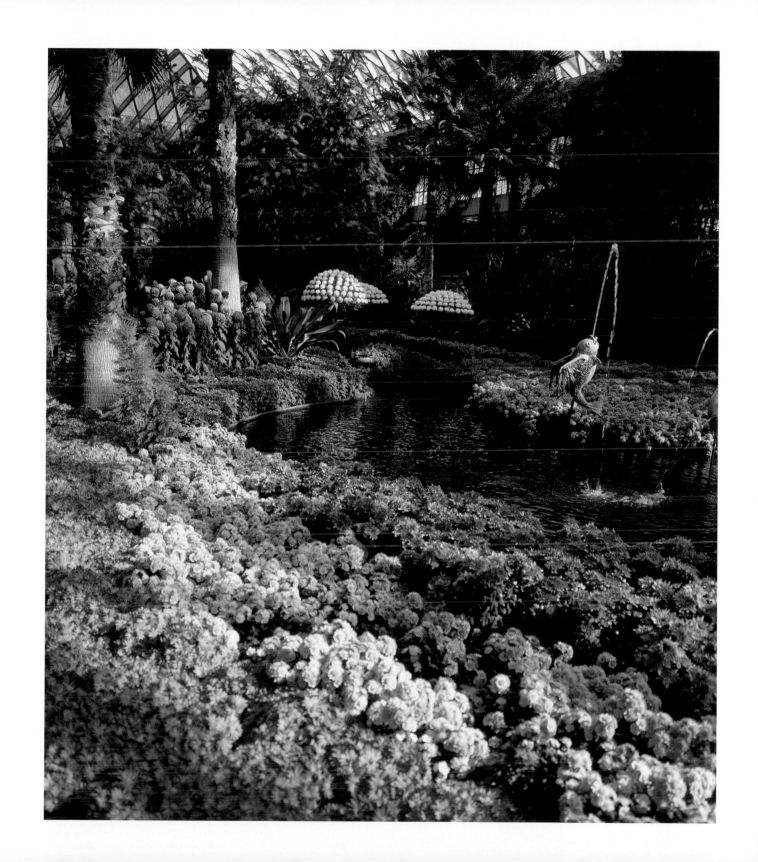

84. Pennsylvania gardens

85. Longwood Gardens,
Kennett Square

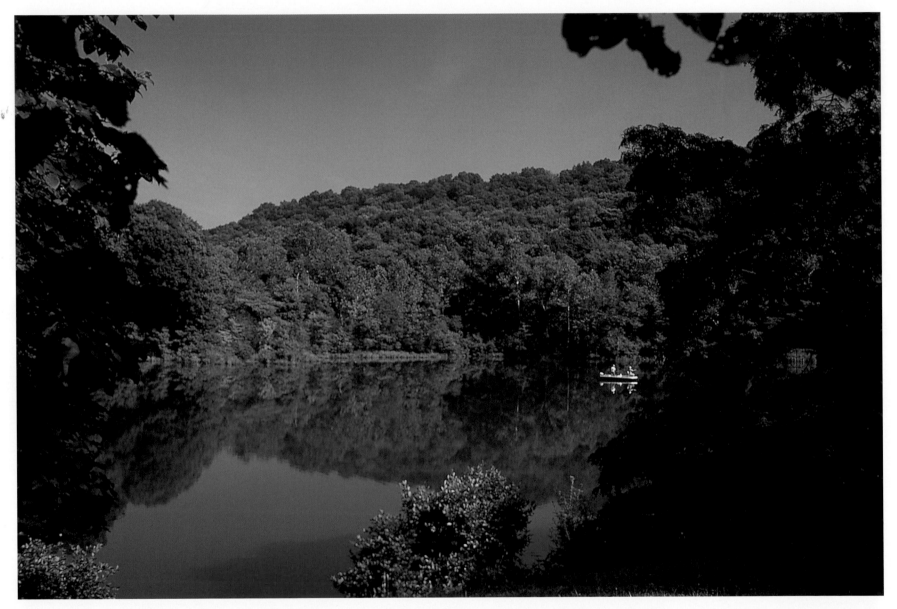

86. Raccoon Creek State Park,
Beaver County

87. Gifford Pinchot State Park,
York County

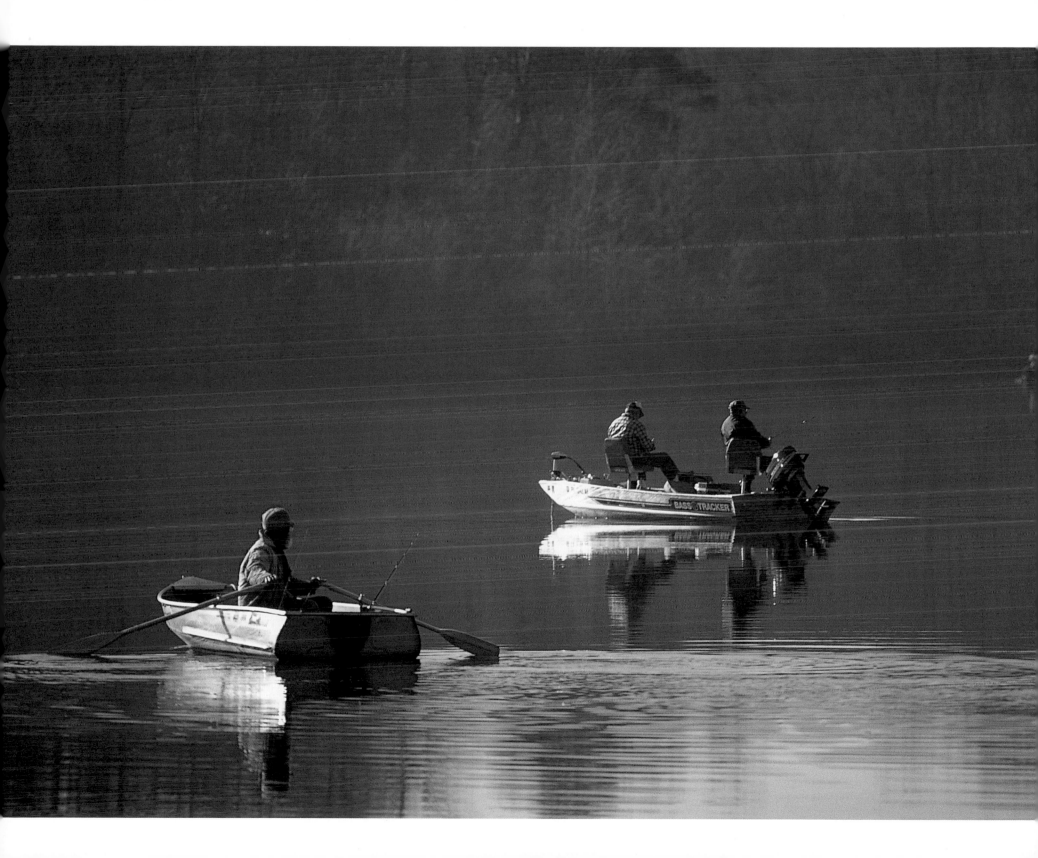

88. Buchanan's Birthplace State Park,
Cove Gap, Franklin County

89. Sugarloaf Mountain,
Conyngham Valley, Luzerne County

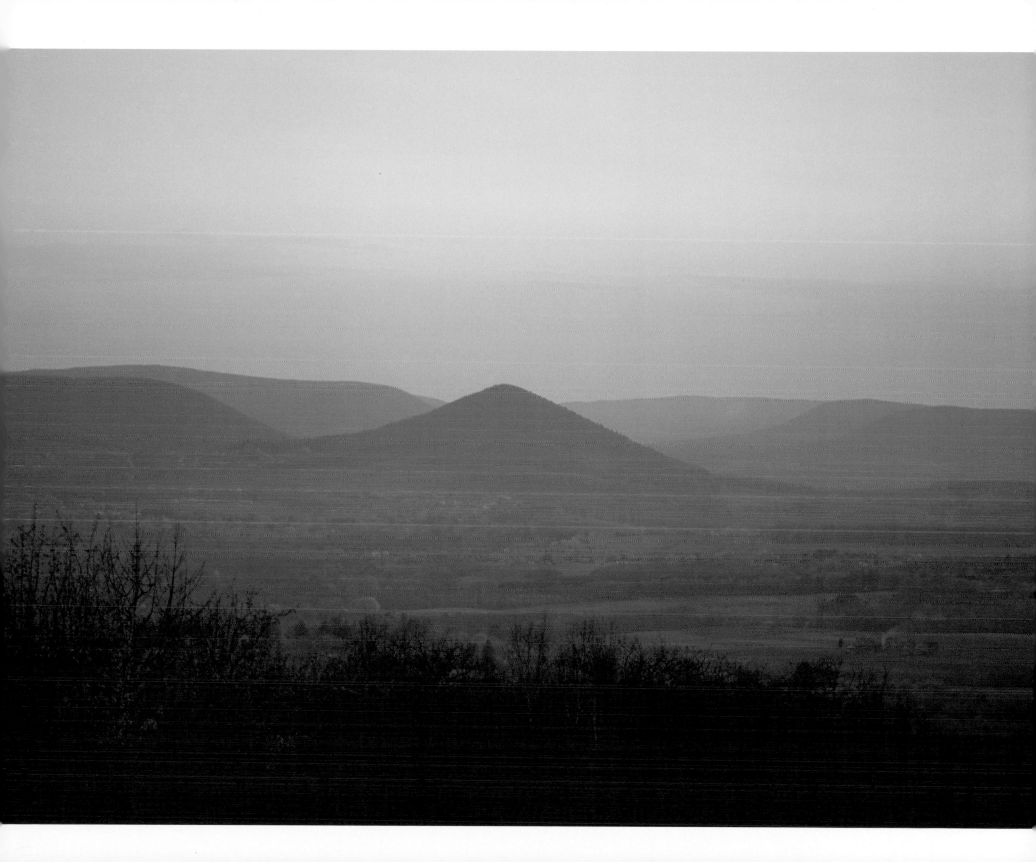

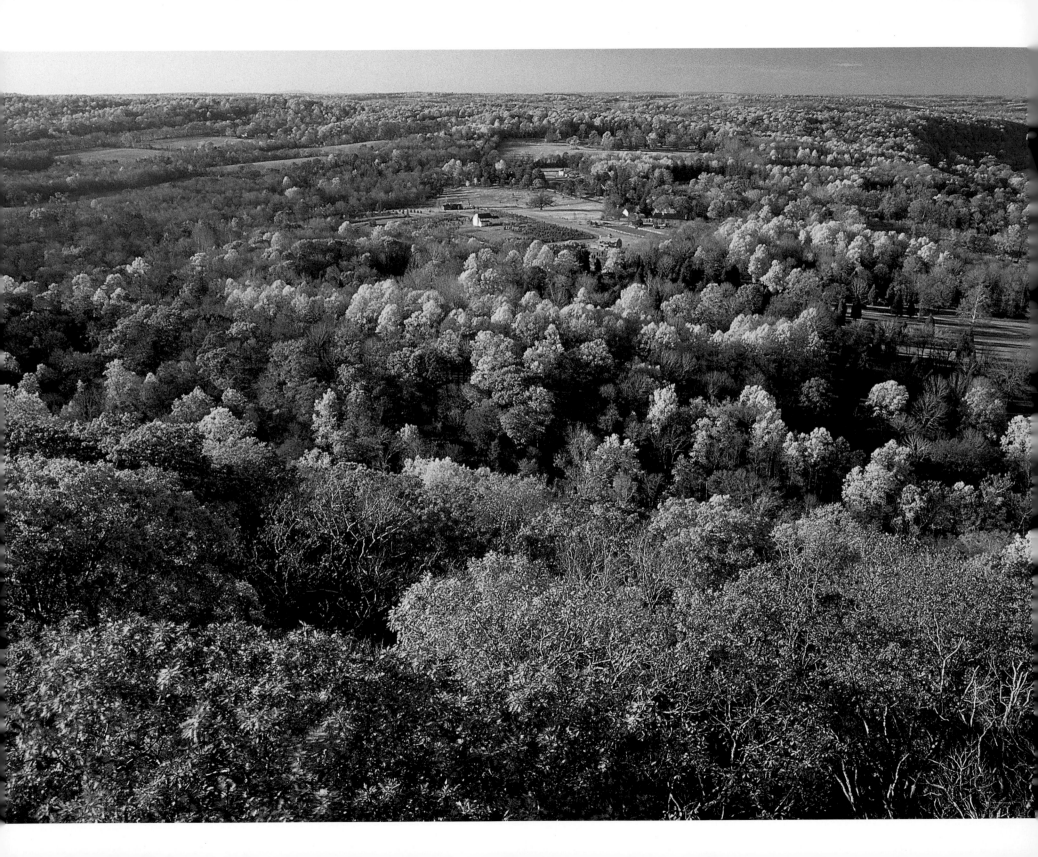

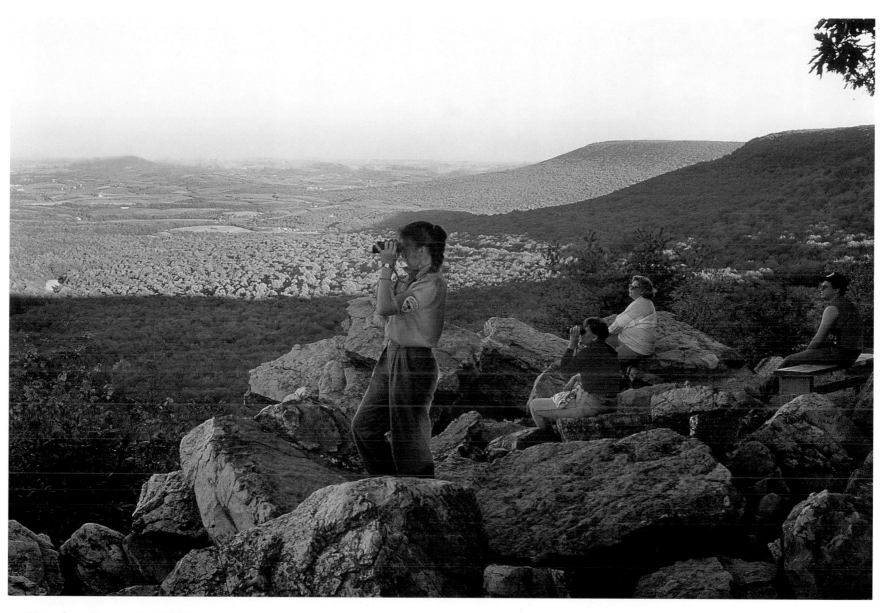

90. View from Bowman's Hill Tower,
Washington Crossing Historic Park

91. Hawk Mountain Sanctuary,
Kempton, Berks County

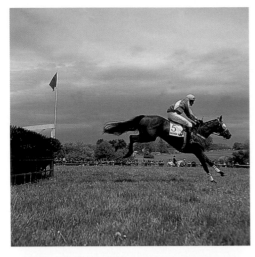 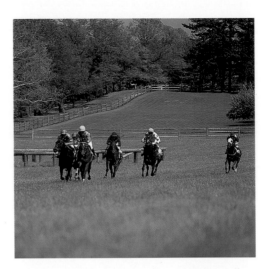

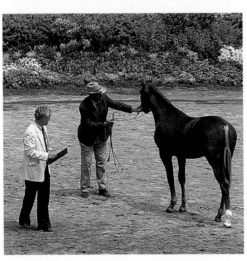 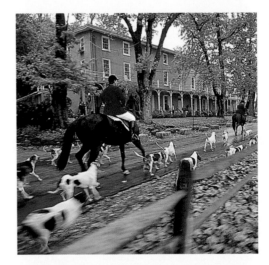

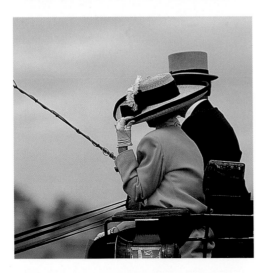 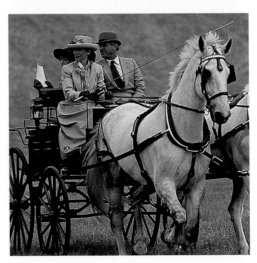

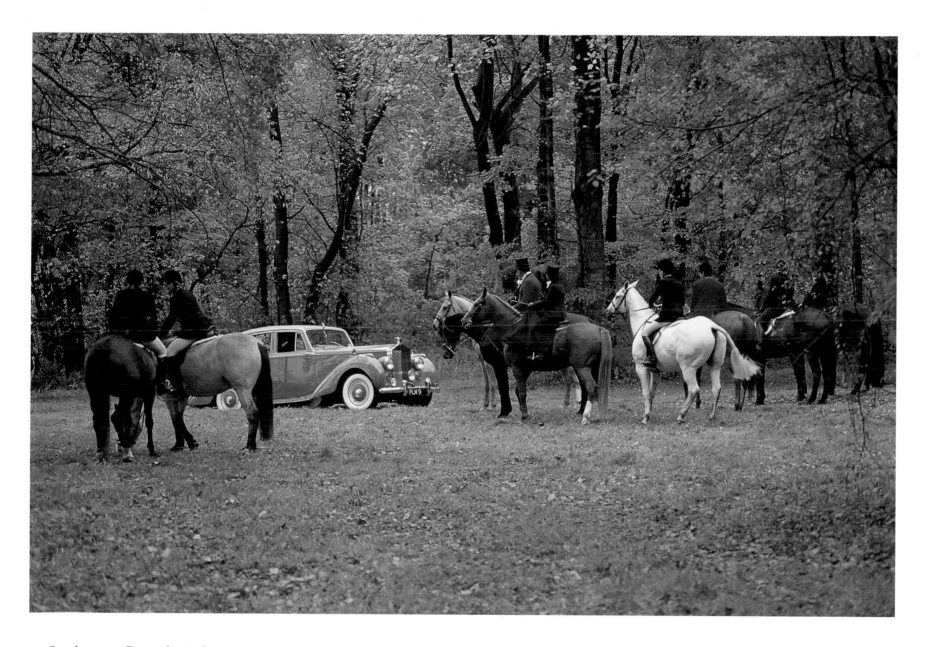

92. Southeastern Pennsylvania horse events:
Devon Horse Show
Radnor Hunt Races
Pickering Hunt

93. Pickering Hunt,
Chester Springs

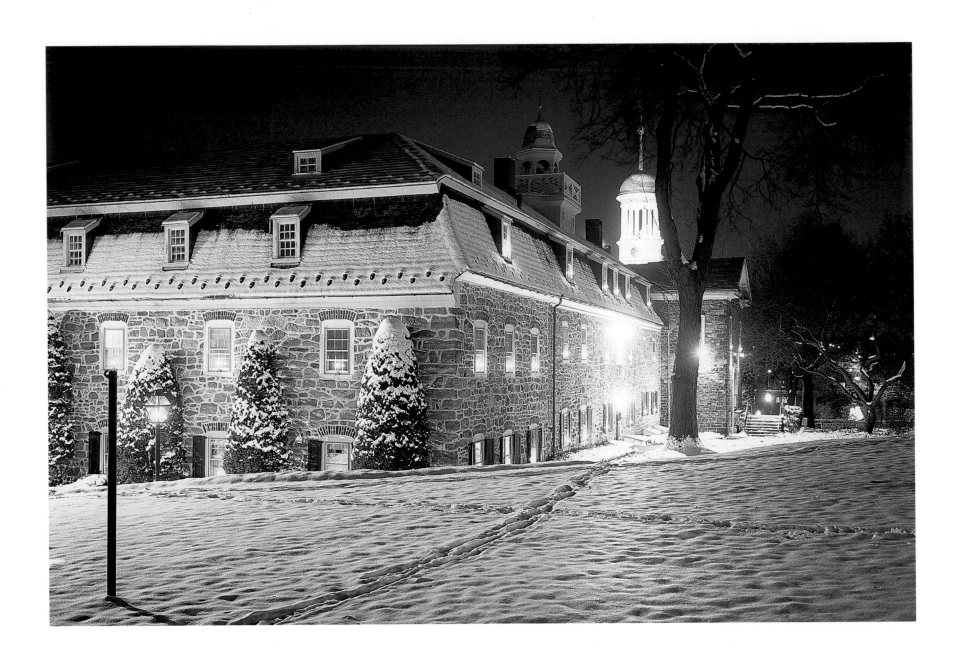

94. The Moravian Museum of Bethlehem

95. The Bourse, Philadelphia

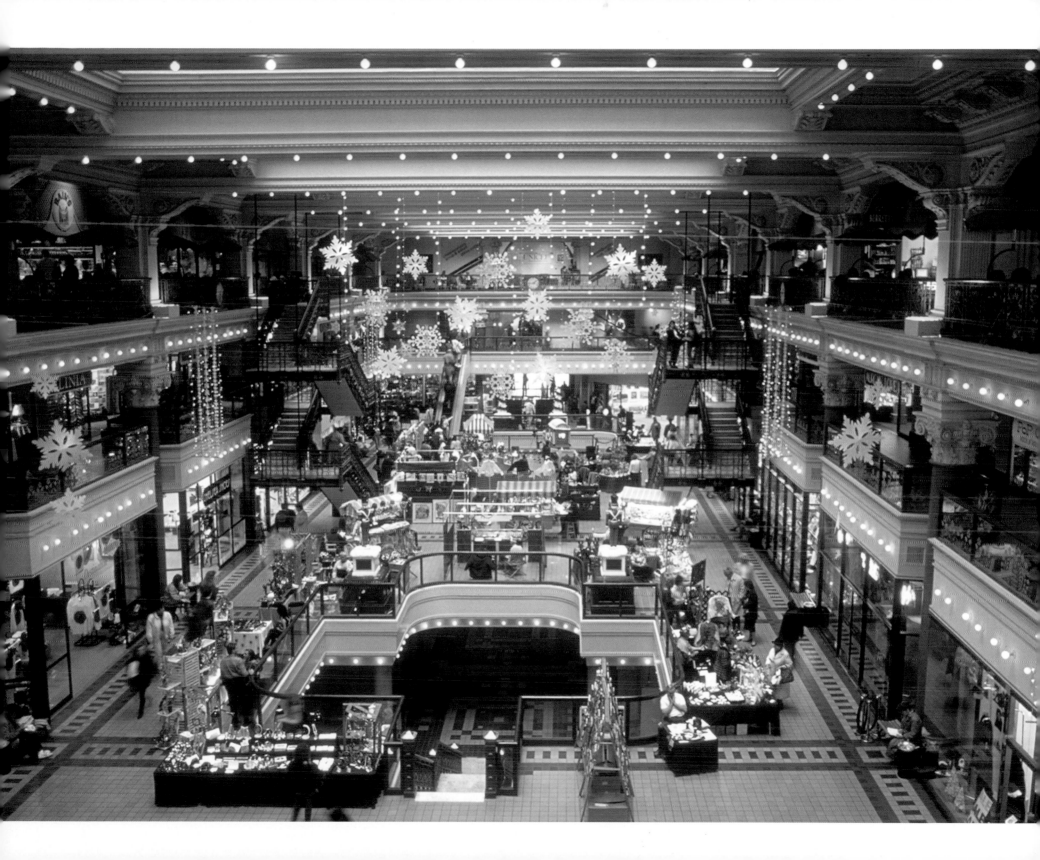

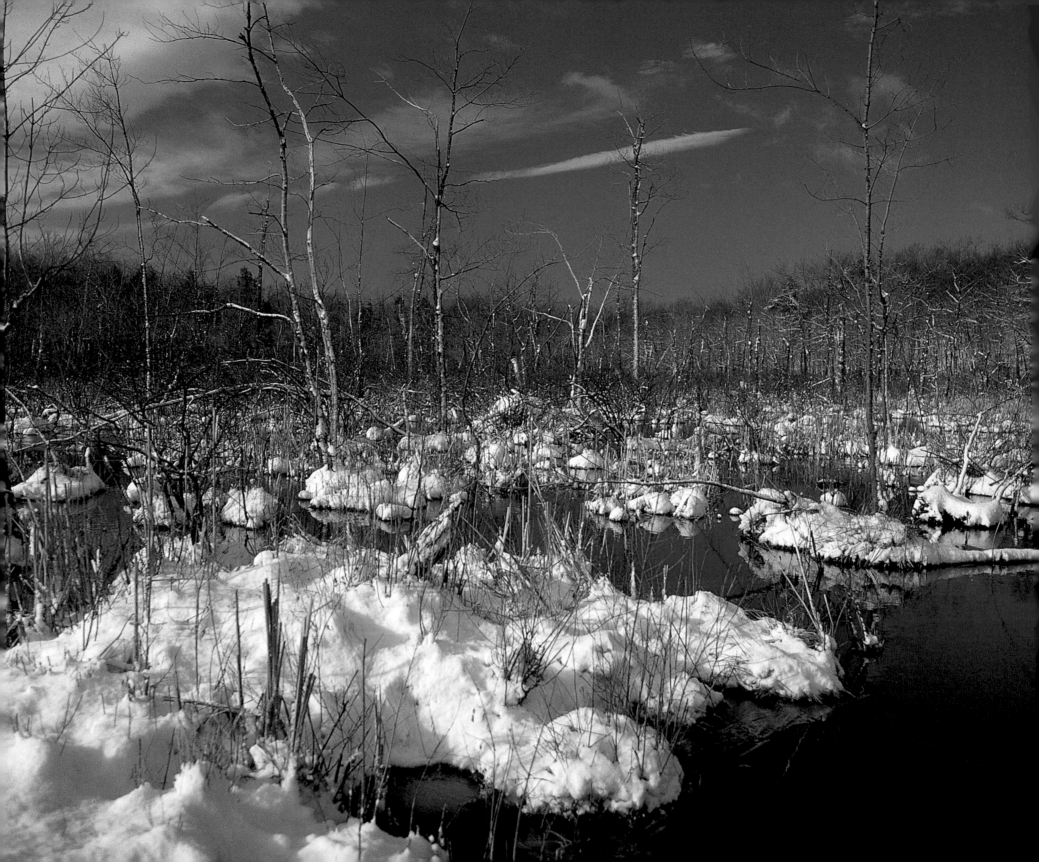

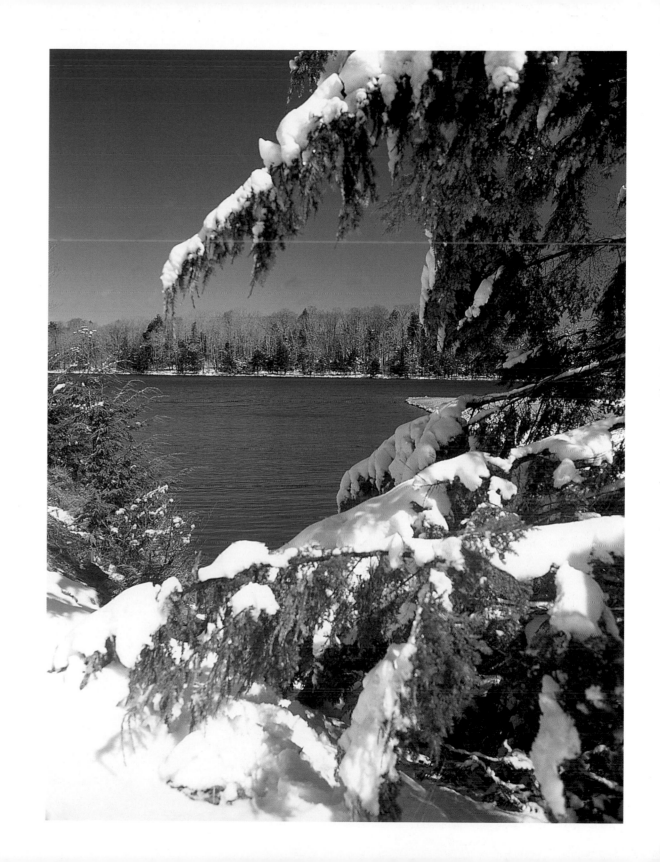

96. Worlds End State Park, Sullivan County

97. Lake Jean, Luzerne County

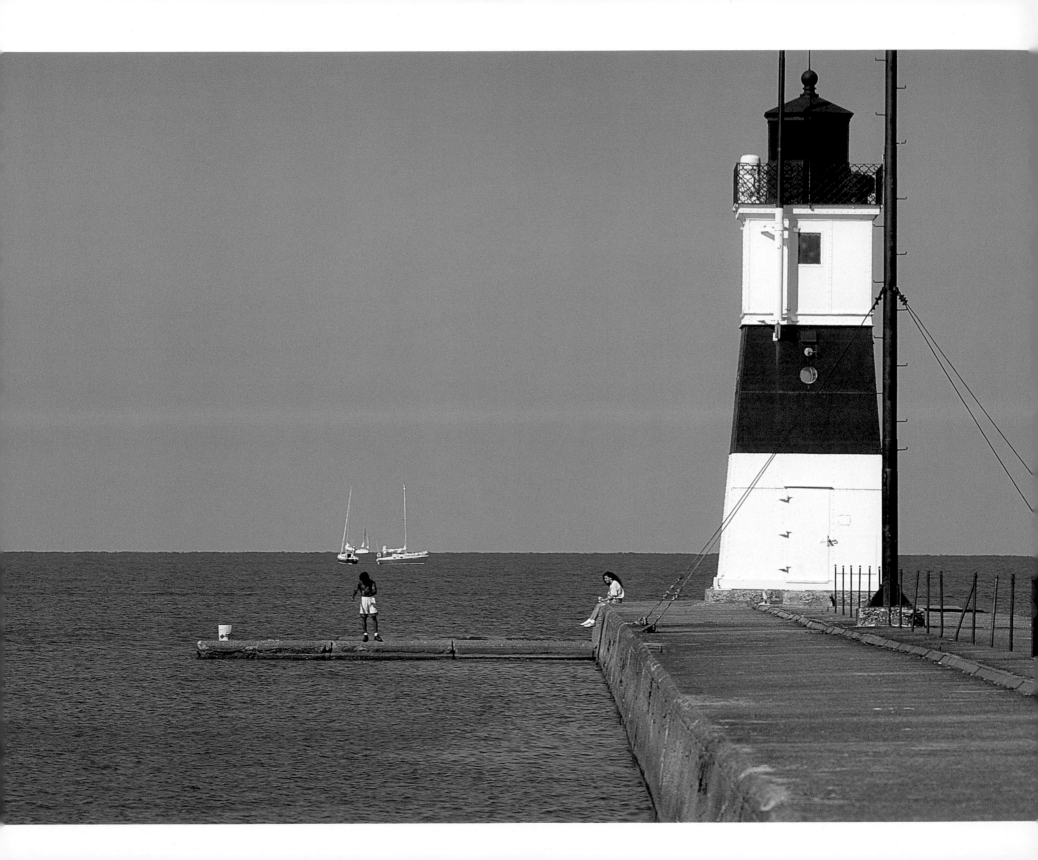

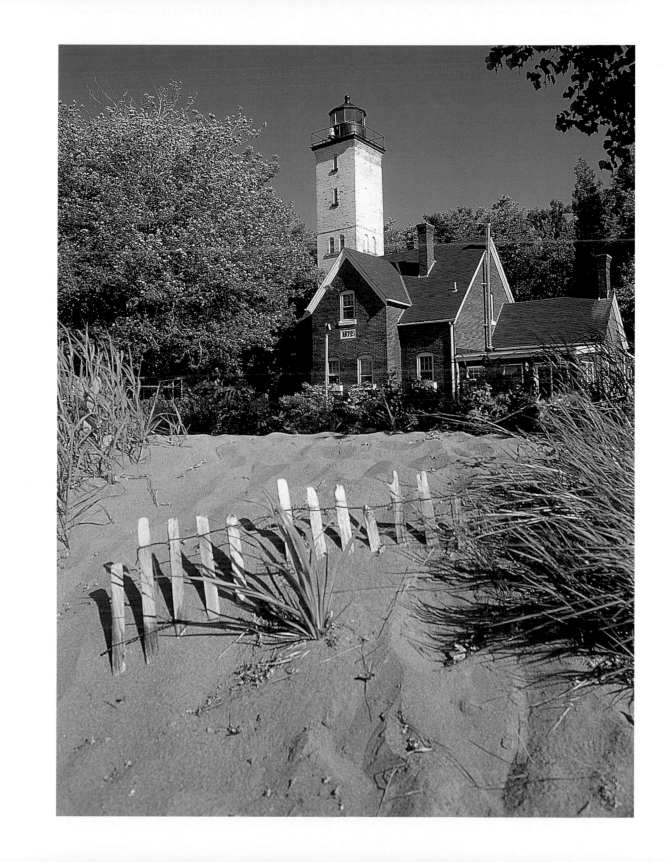

98. Erie Harbor North Pierhead Light, Erie

99. Presque Isle Light, Erie

100 -101. Hopewell Furnace
National Historic Site, Elverson

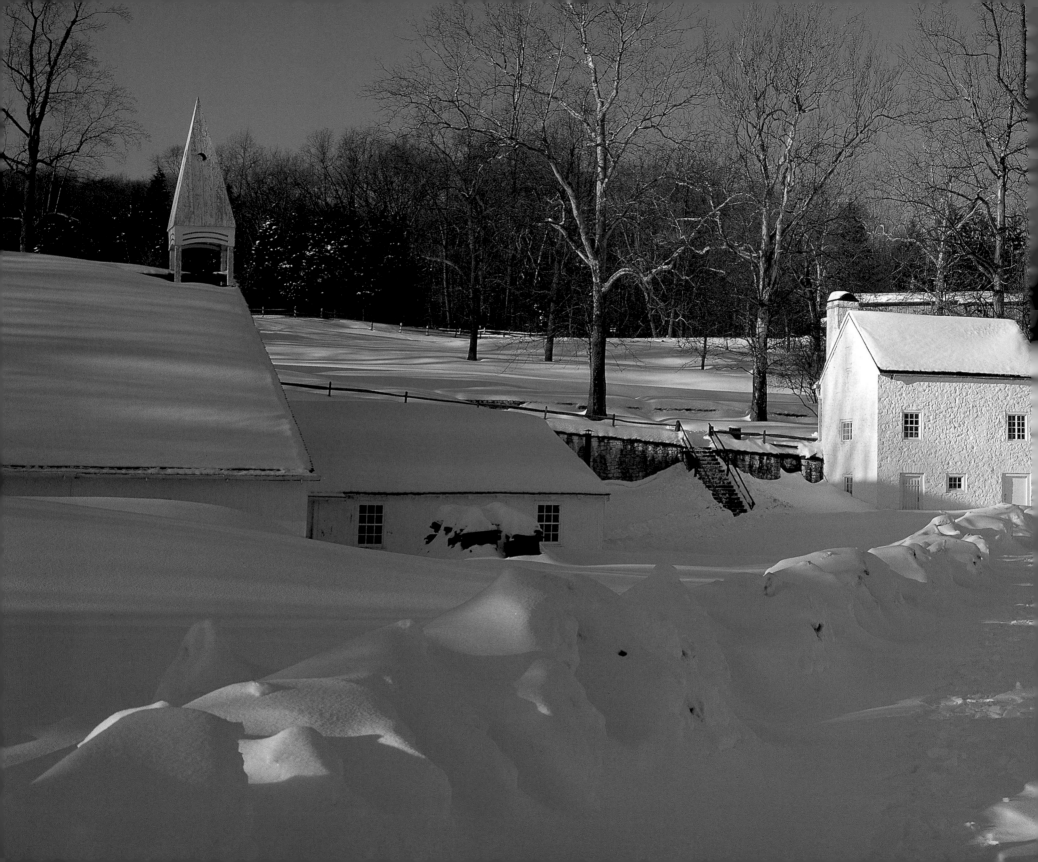

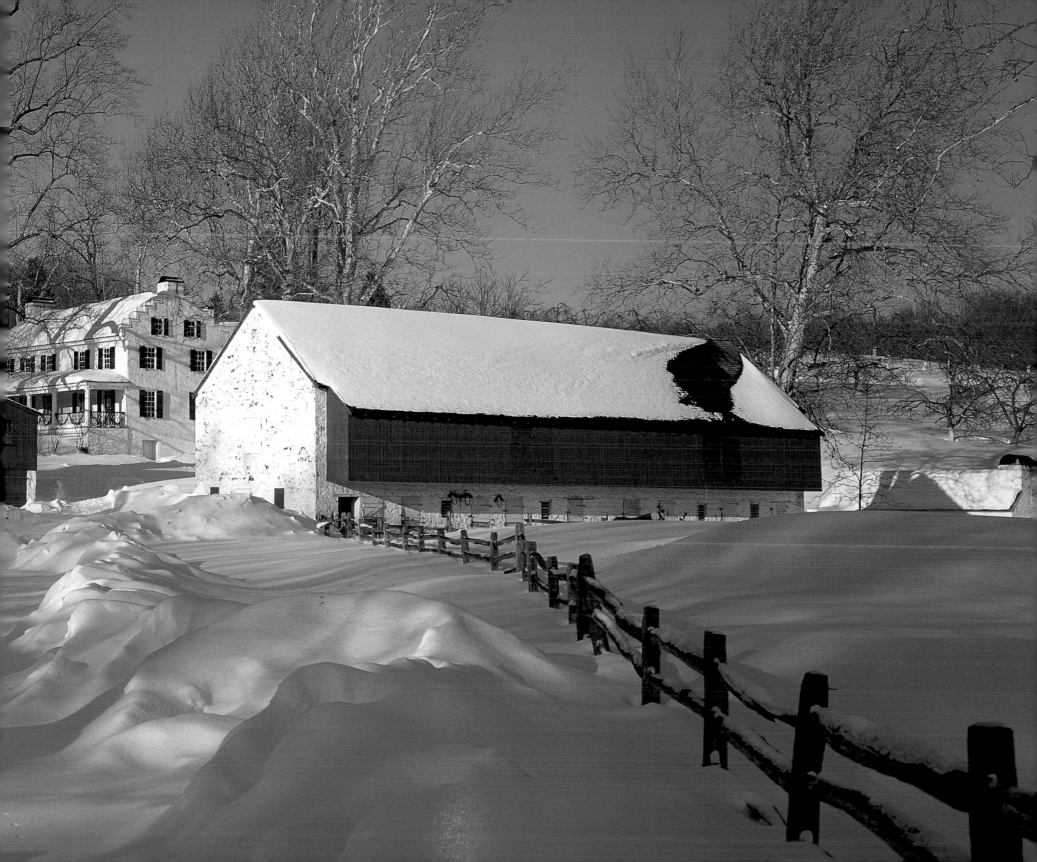

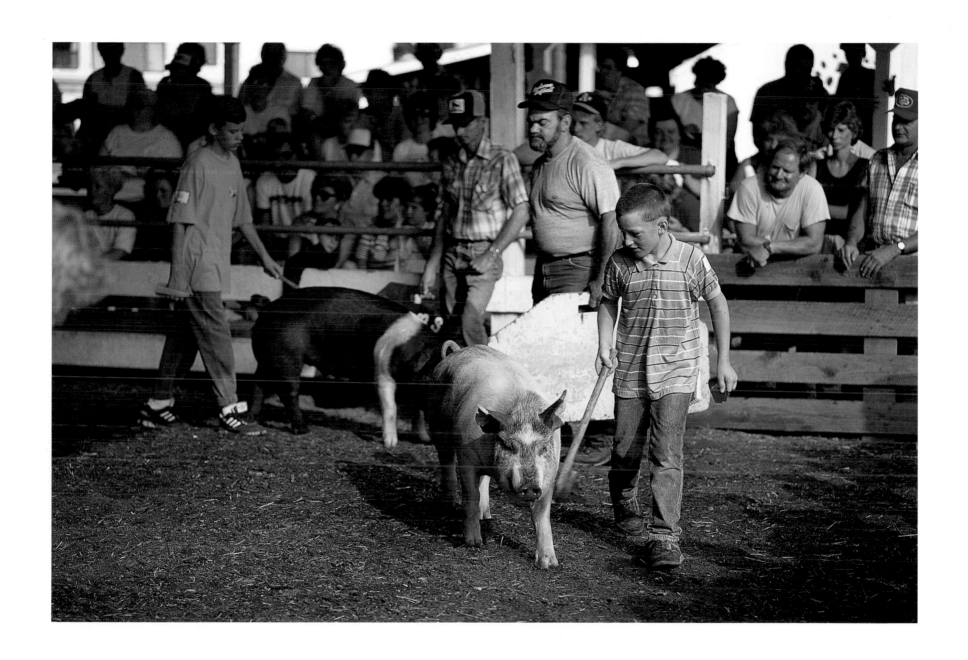

102. Brandywine River Museum,
Chadds Ford

103. Centre County Grange Fair,
Centre Hall

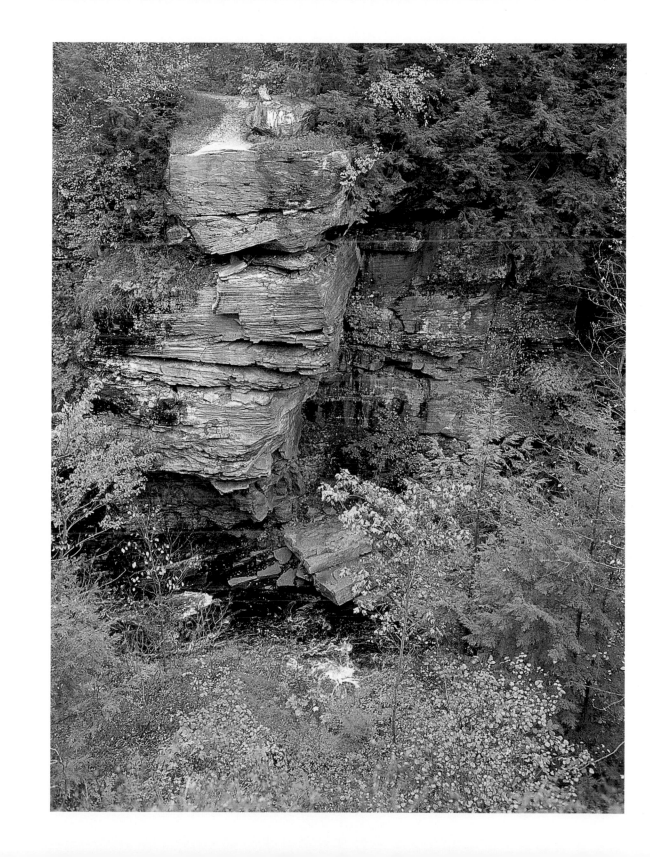

104. Balanced Rock,
Trough Creek State Park,
Huntingdon County

105. Shohola Creek,
Pike County

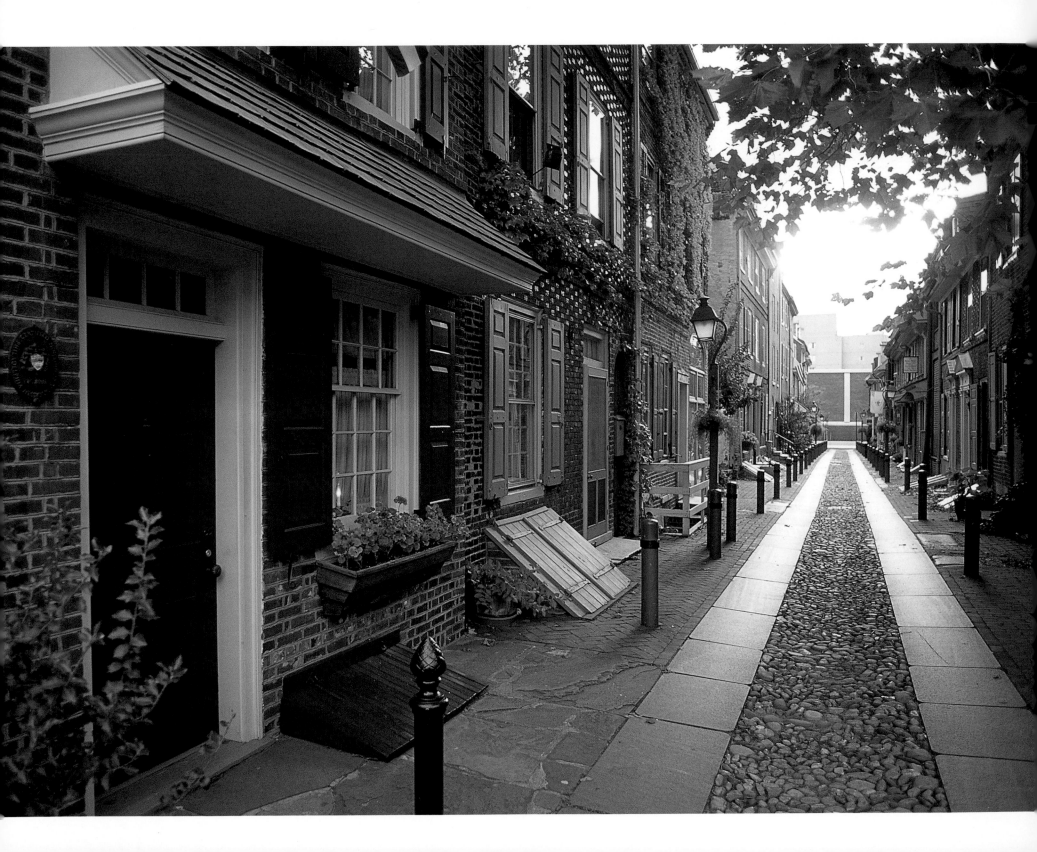

106. Elfreth's Alley, Philadelphia

107. Petersburg Toll House, Addison

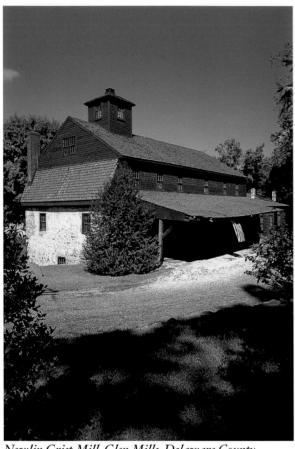

Newlin Grist Mill, Glen Mills, Delaware County

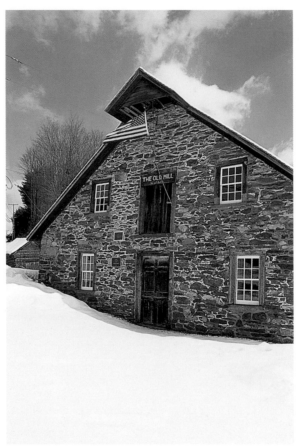

Fenner-Snyder Mill, Sciota, Monroe County

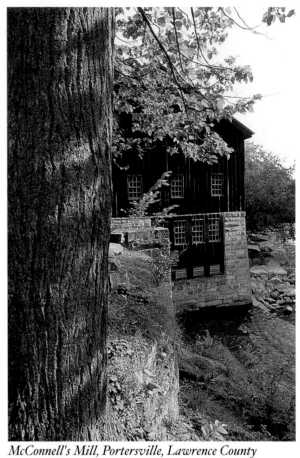

McConnell's Mill, Portersville, Lawrence County

108. Pennsylvania mills

109. Haines Mill Museum,
Cetronia, Lehigh County

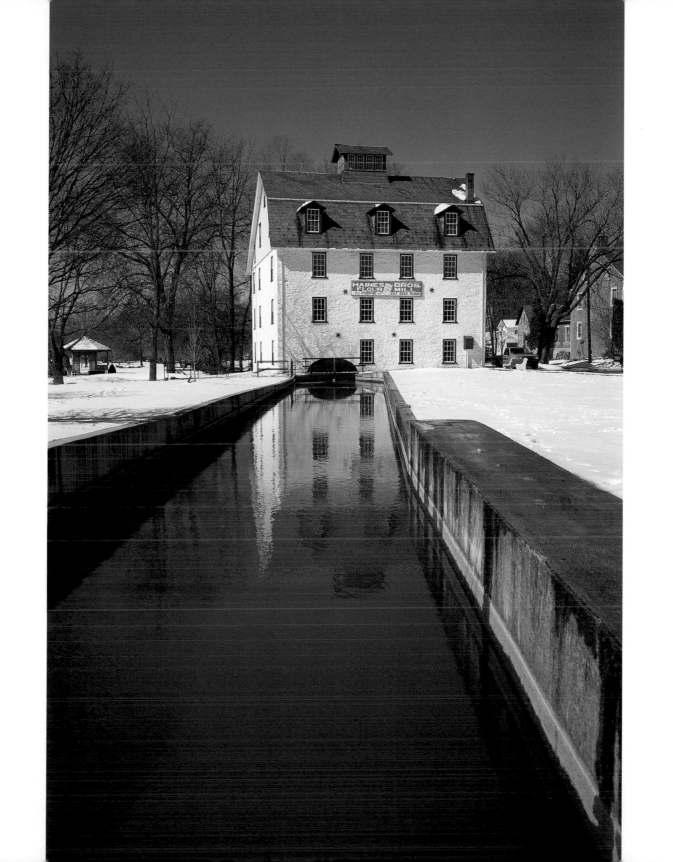

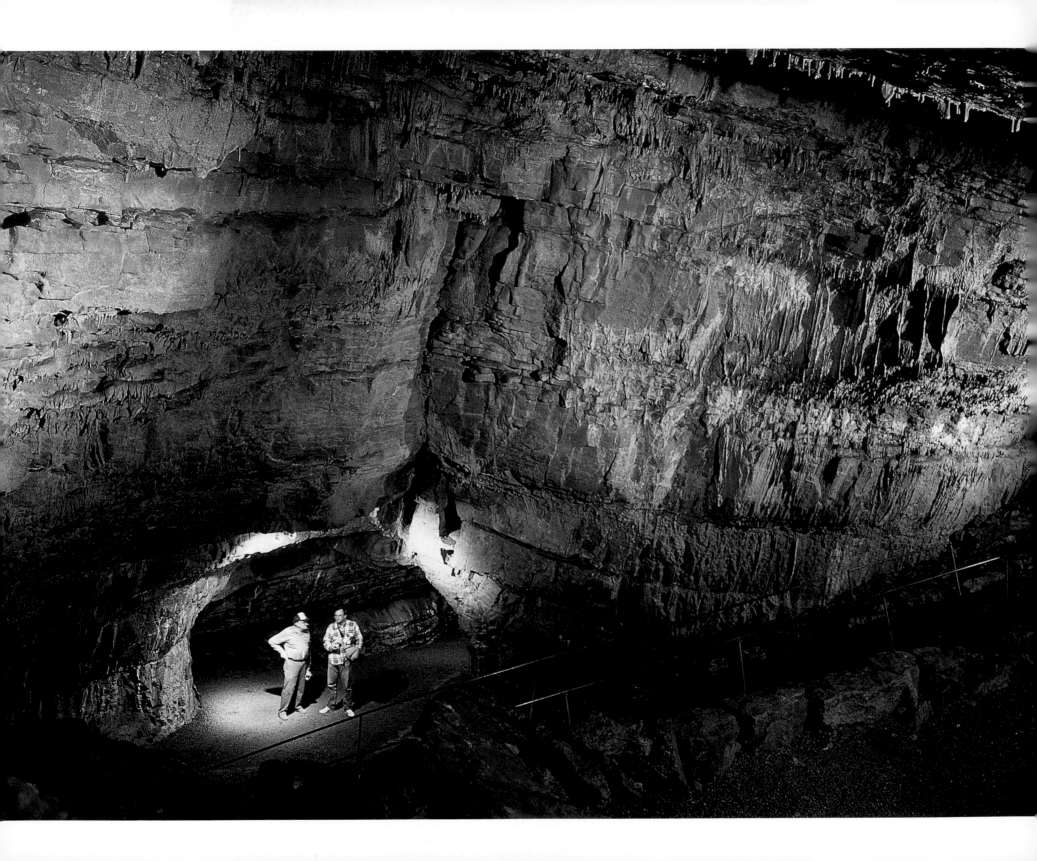

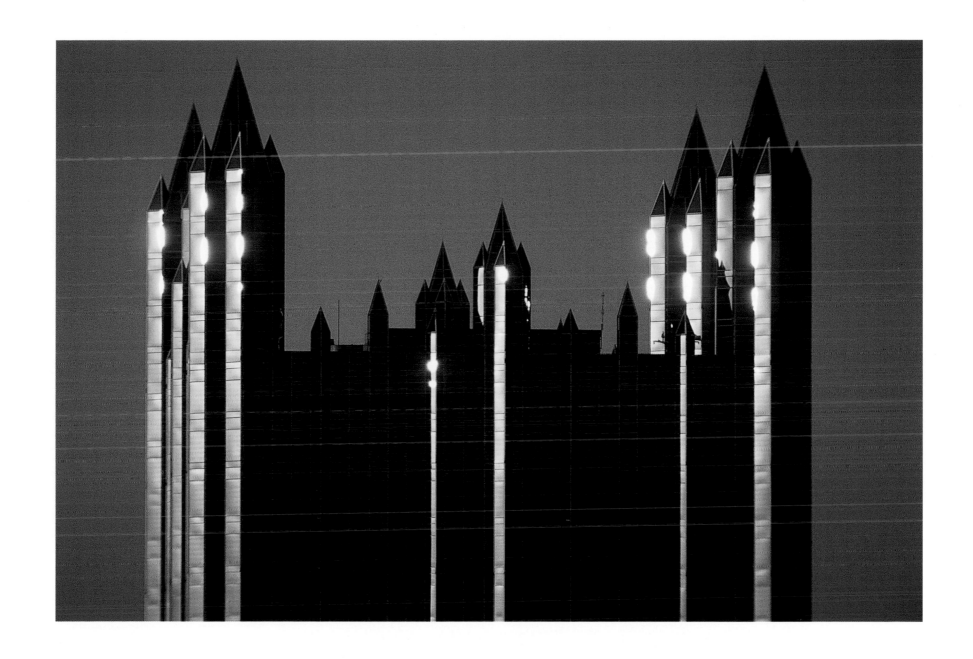

110. Woodward Cave, Centre County

111. PPG Place, Pittsburgh

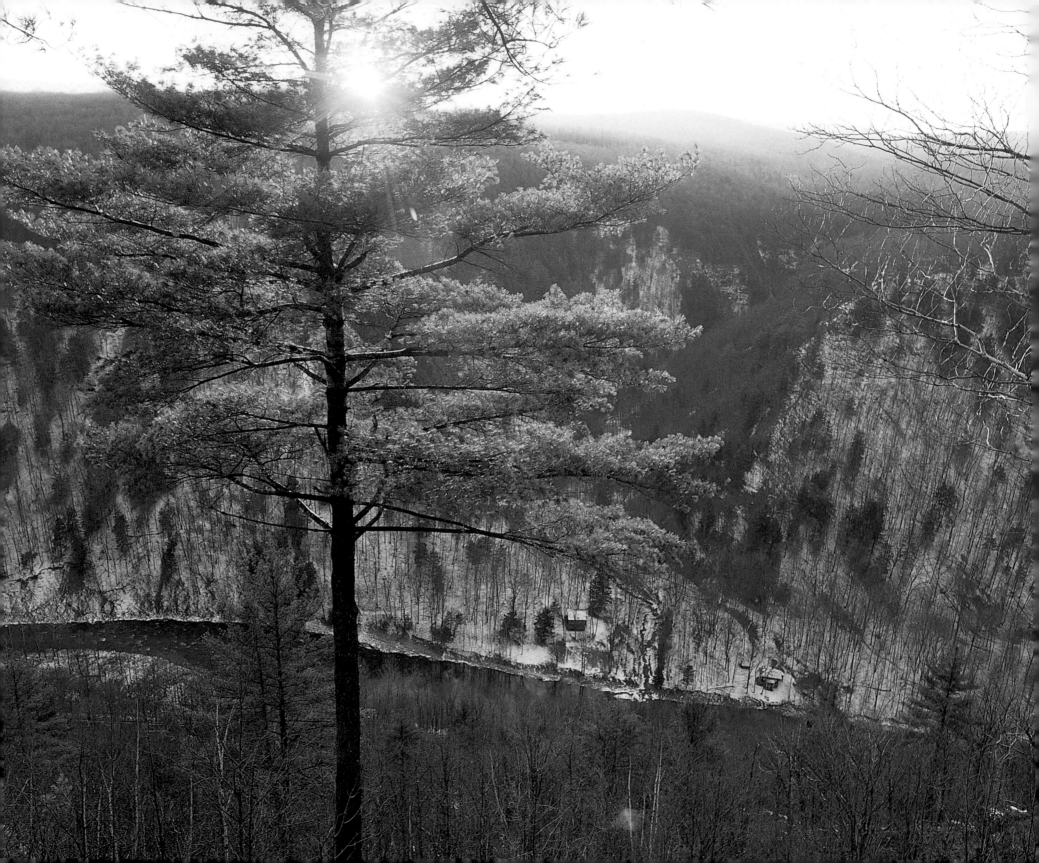

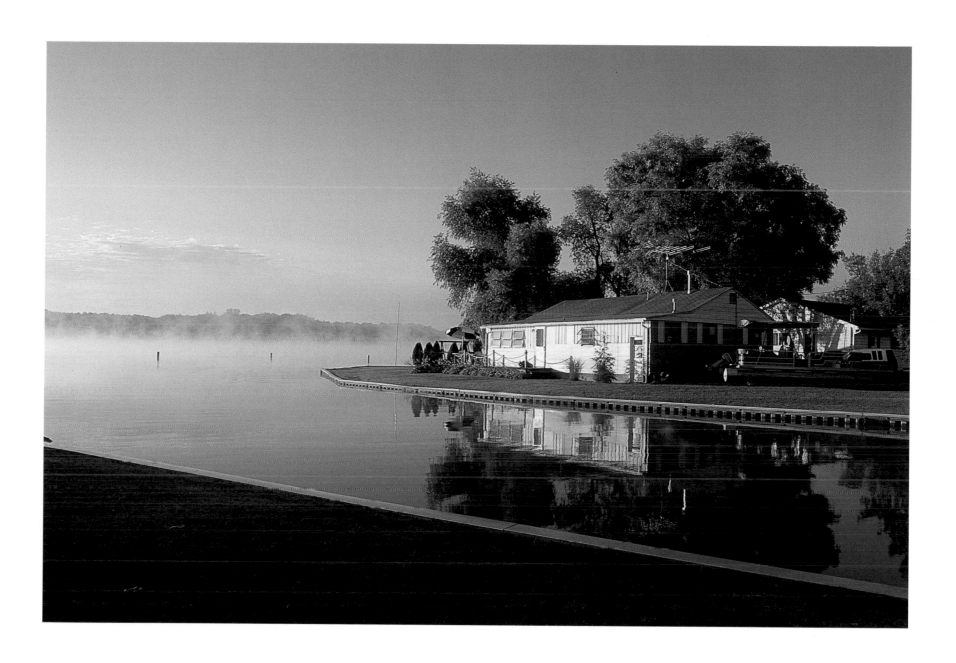

112. Pine Creek Gorge,
Leonard Harrison State Park,
Tioga County

113. Conneaut Lake,
Crawford County

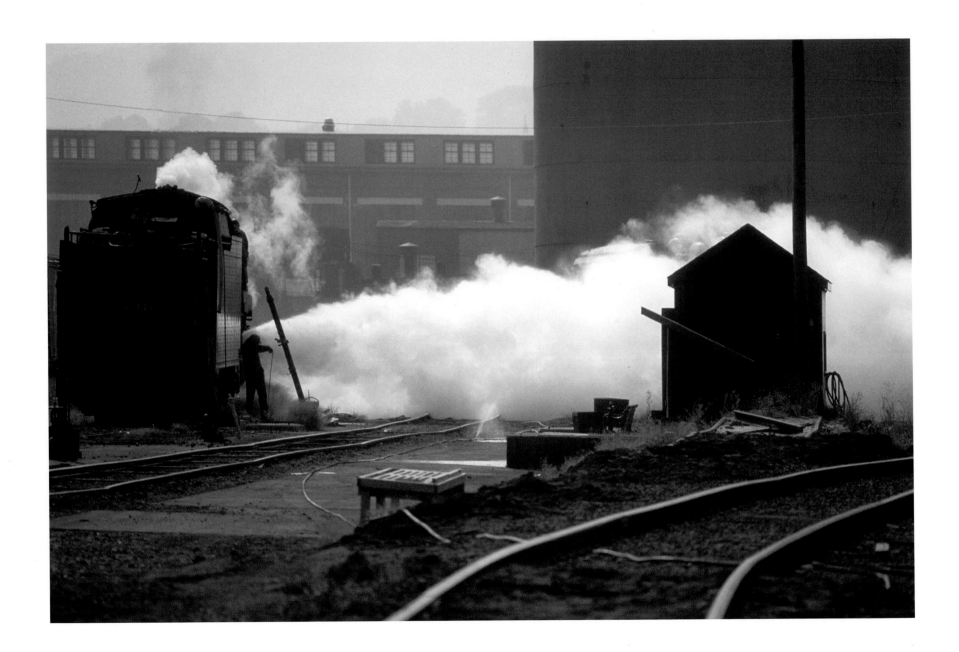

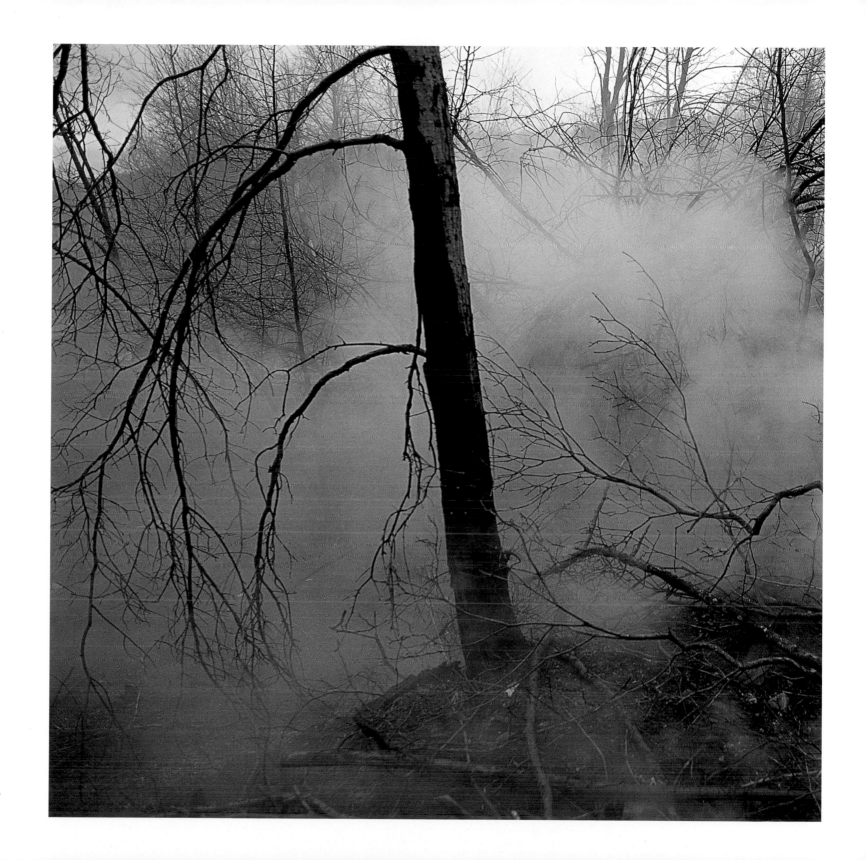

114. Steamtown National
Historic Site, Scranton

115. Mine fires, Centralia,
Schuylkill County

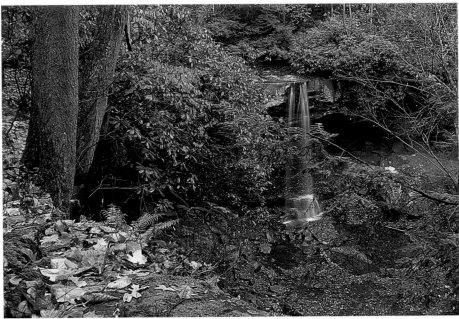

Cucumber Falls, Ohiopyle State Park, Fayette County

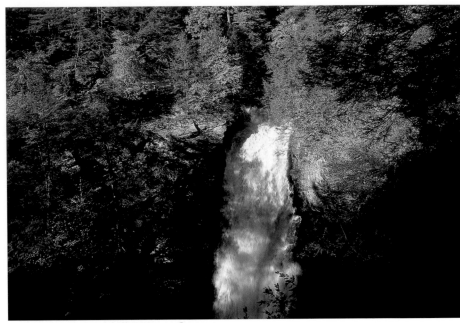

Bushkill Falls, Bushkill, Monroe County

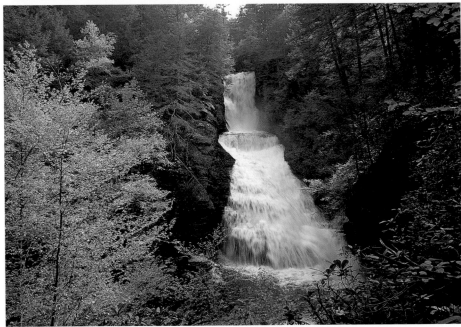

Dingmans Falls, Delaware Water Gap N.R.A., Pike County

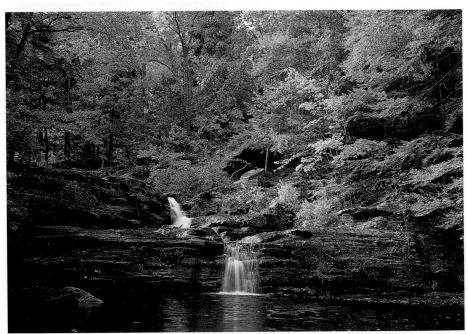

Factory Falls, Childs Recreation Area, Delaware Water Gap N.R.A., Pike County

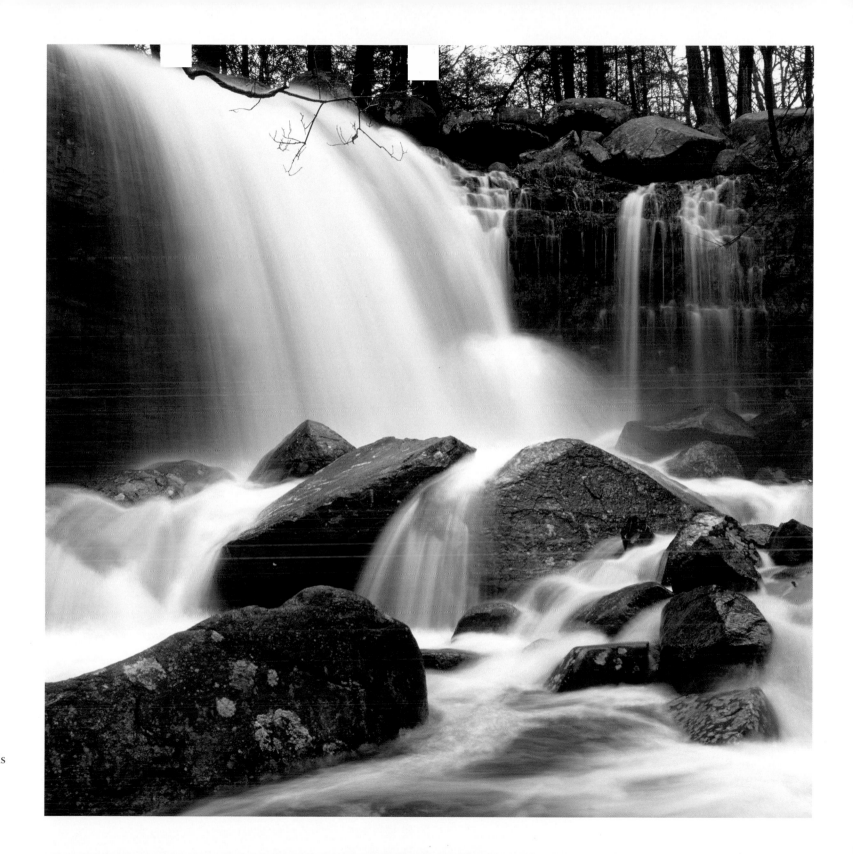

116. Pennsylvania waterfalls

117. Falls Creek,
Tinicum, Bucks County

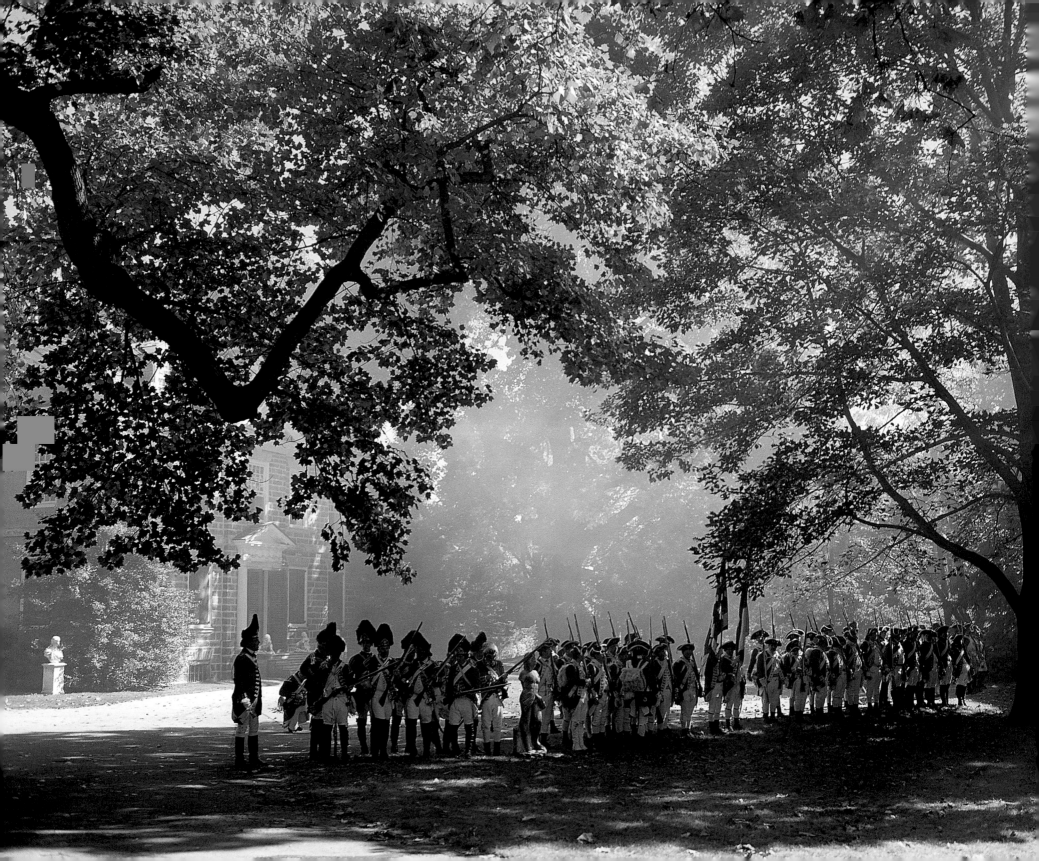

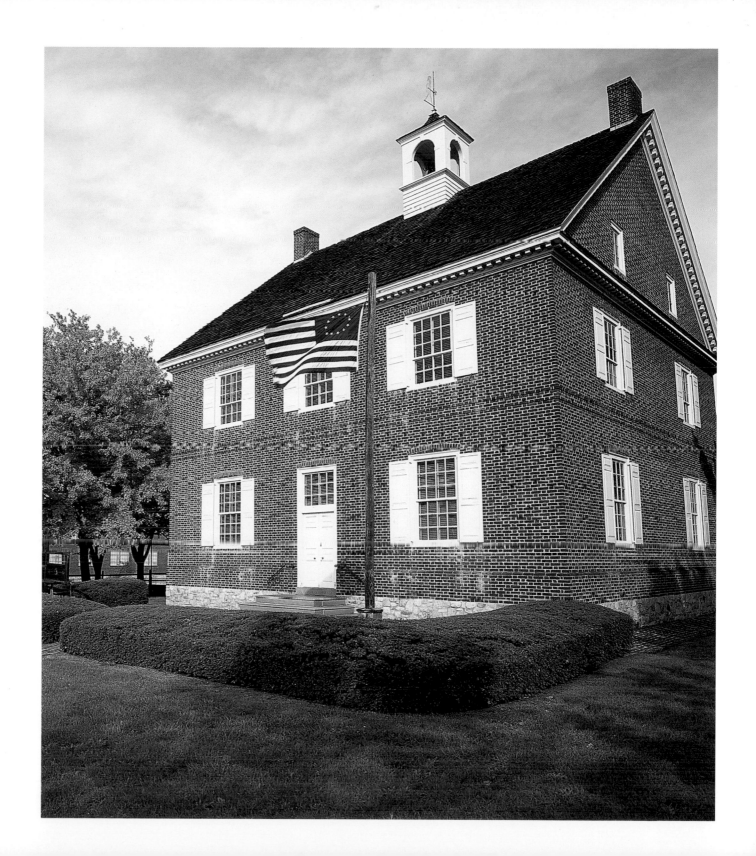

118. Reenactment,
Battle of Germantown,
Phildadelphia

119. Colonial Courthouse,
York

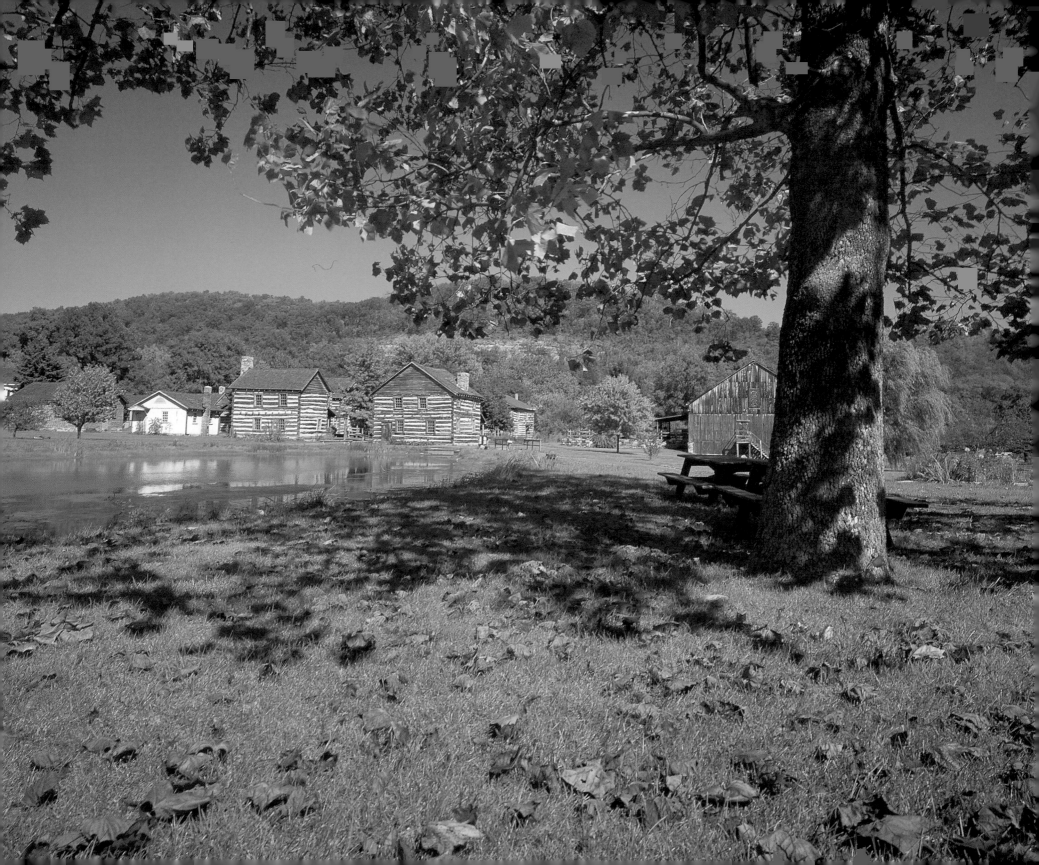

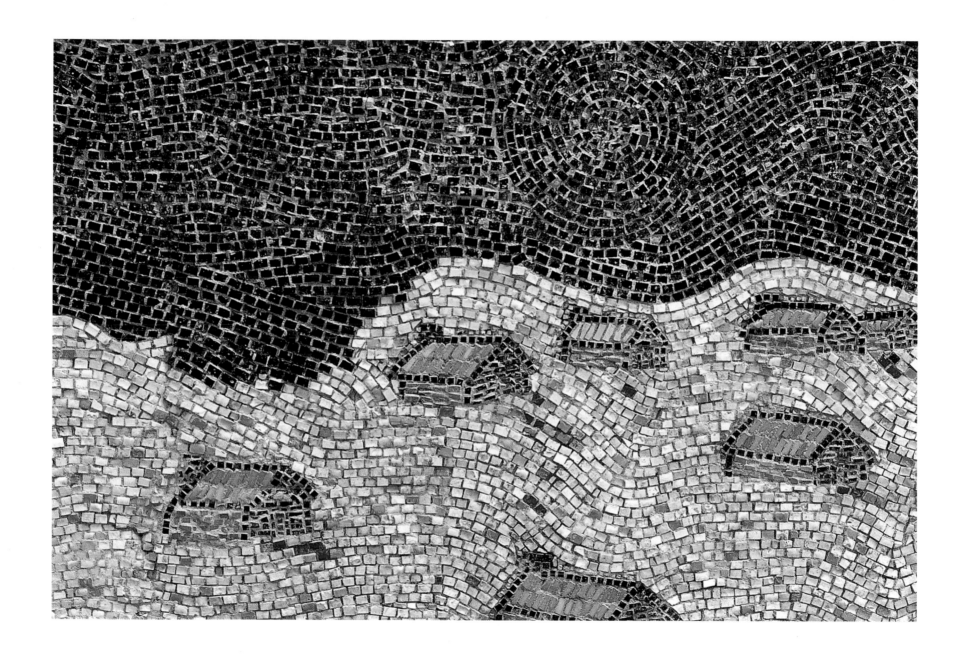

120. Historic Bedford Village, Bedford County

121. Valley Forge, Montgomery County

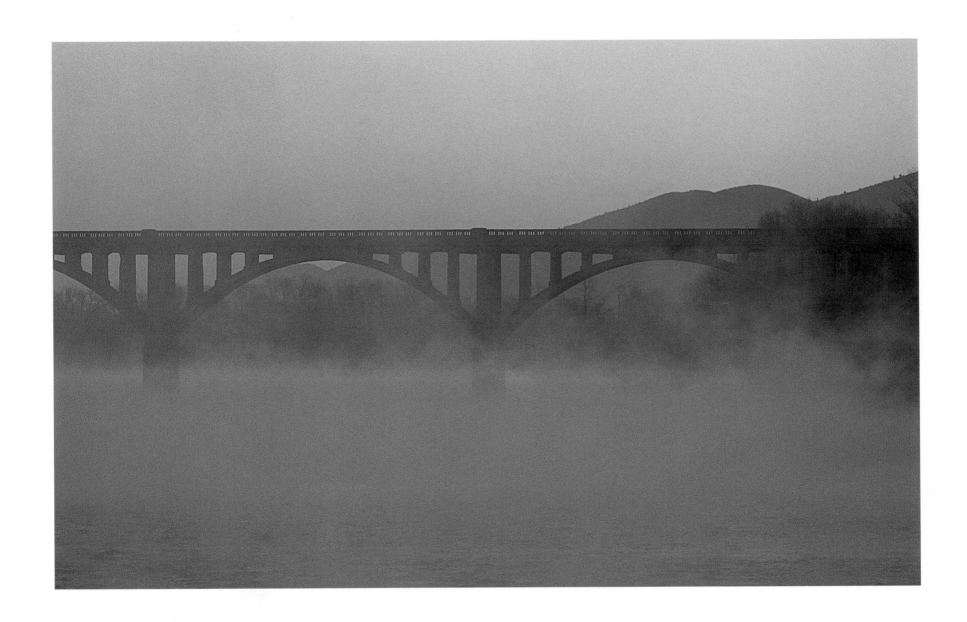

122. West Branch Susquehanna River,
Lock Haven

123. Delaware River, Yardley

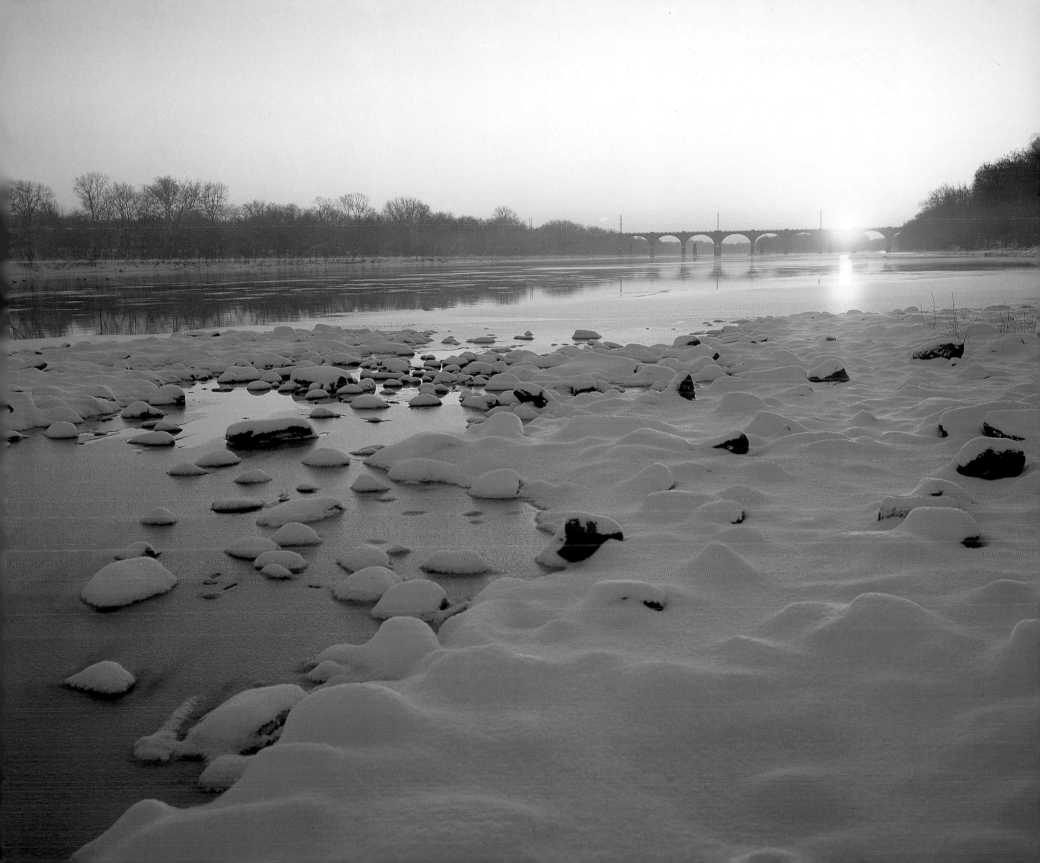

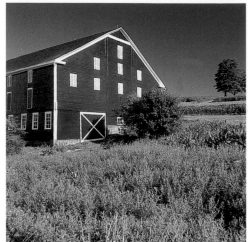

Somerset County

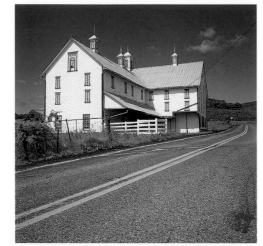

Adams County

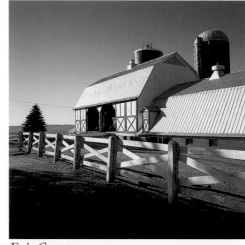

Erie County

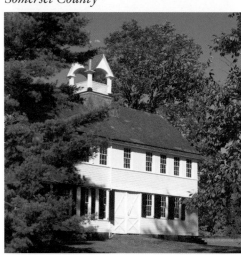

Bucks County

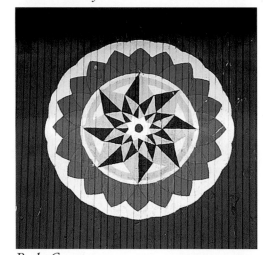

Berks County

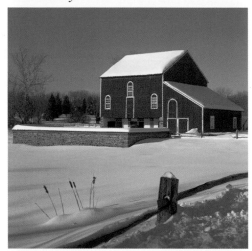

Berks County

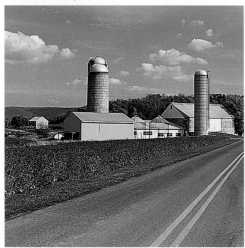

Lebanon County

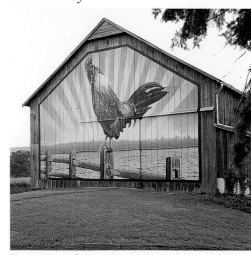

Lancaster County

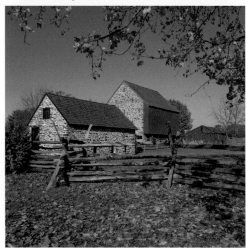

Montgomery County

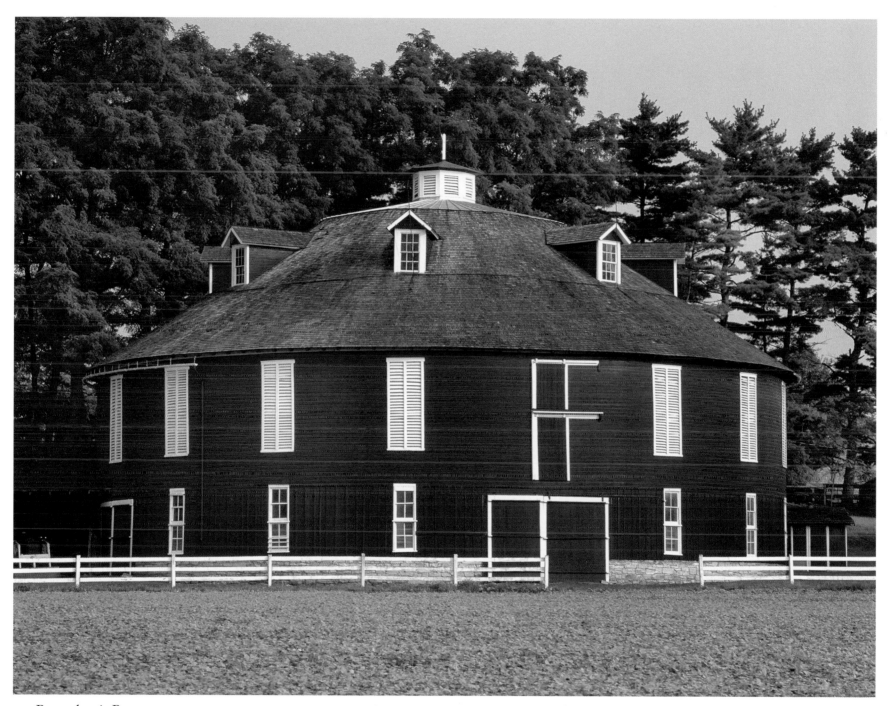

124. Pennsylvania Barns

125. Neff Round Barn, Potter Township, Centre County

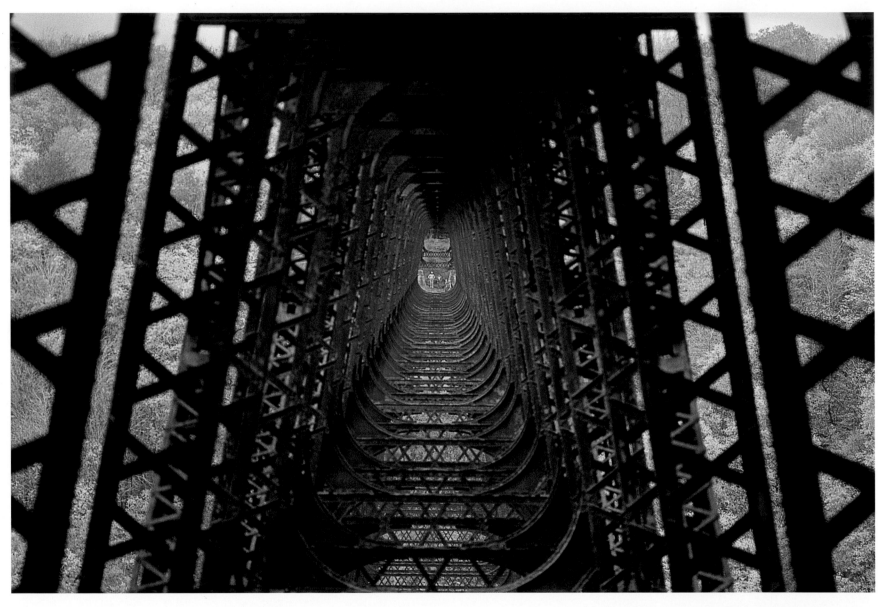

126. Kinzua Viaduct, Kinzua Bridge State Park,
McKean County

127. Second Bank of the United States,
Philadelphia

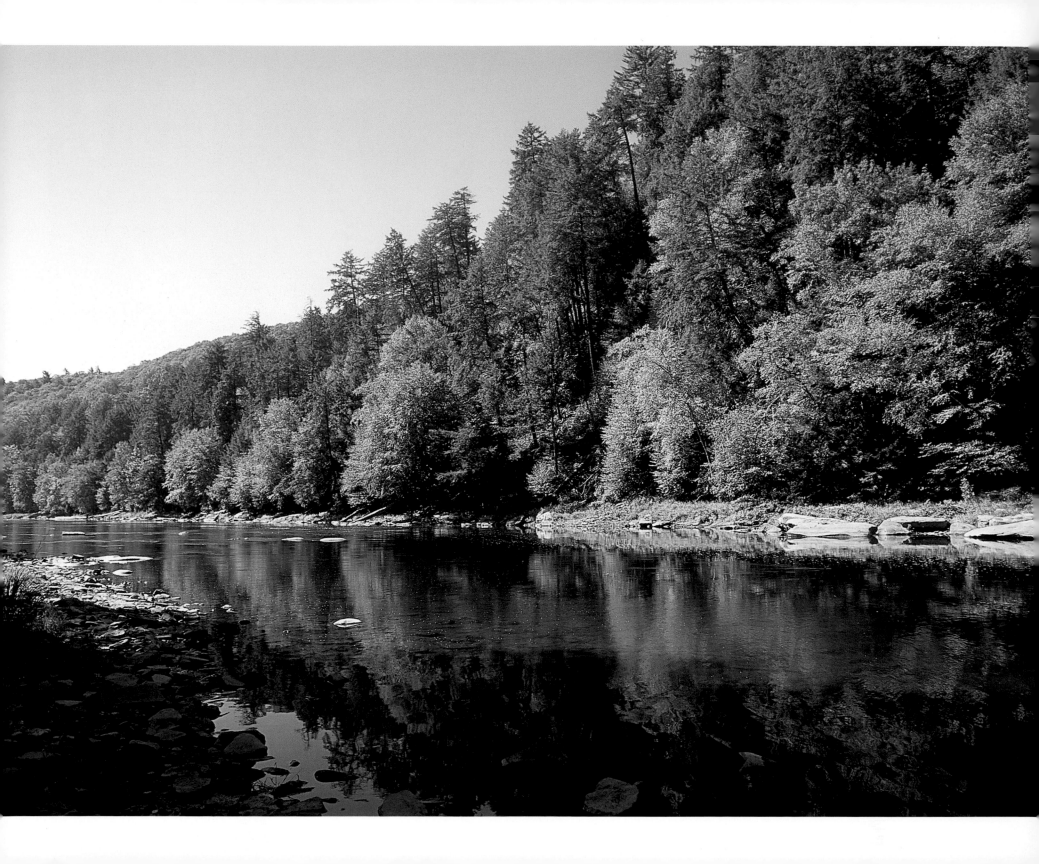

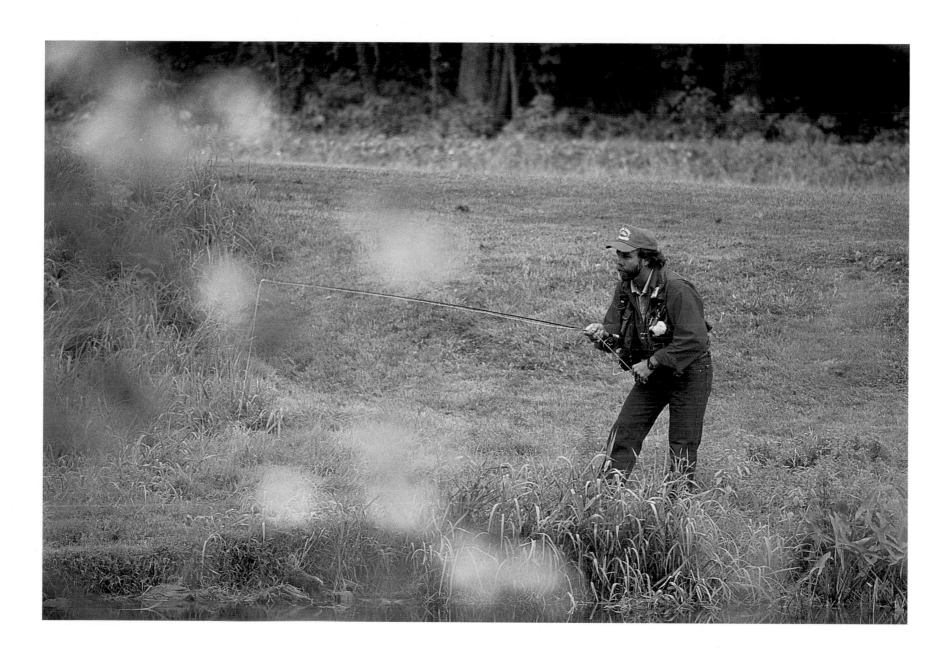

128. Clarion River,
Cook Forest State Park,
Clarion County

129. Fisherman's Paradise,
Spring Creek, Bellefonte

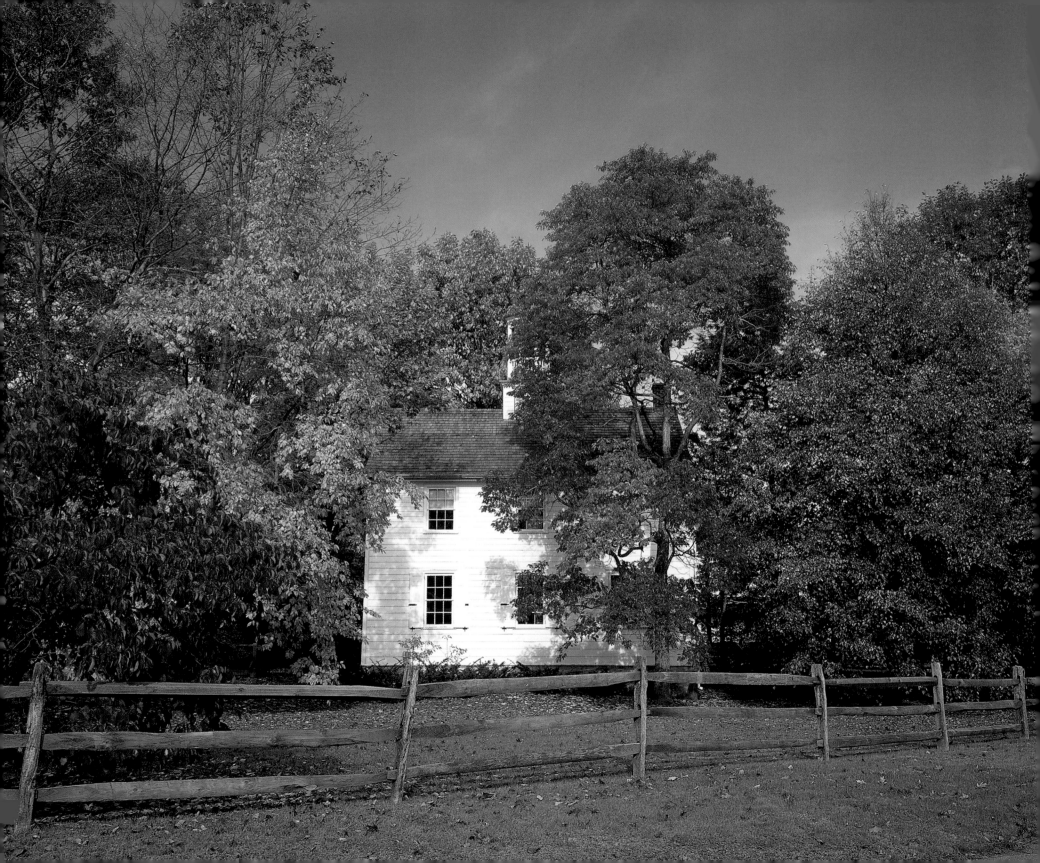

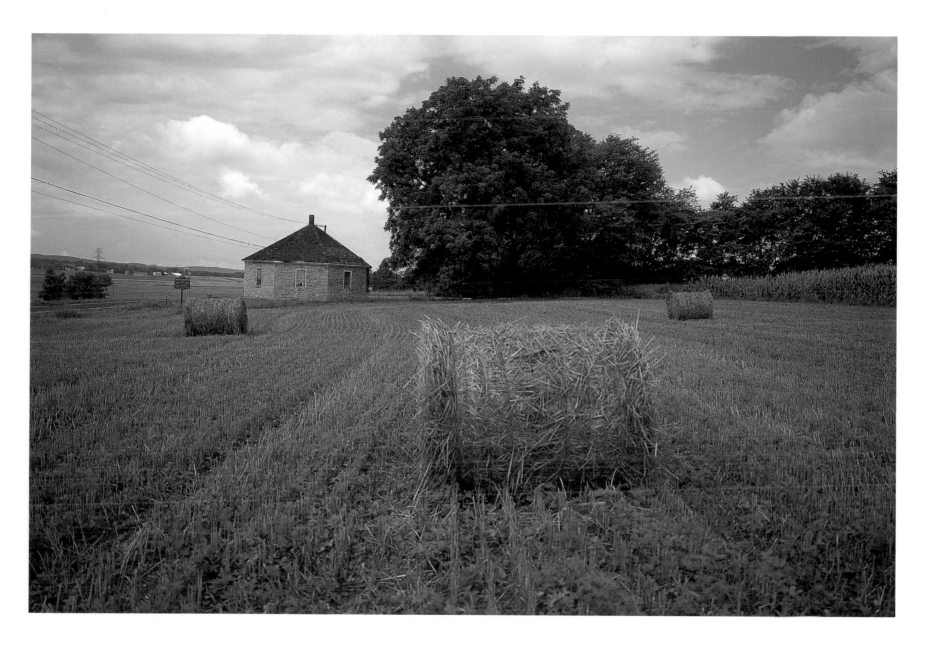

130. Academy Building, 1837,
Ephrata Cloister Museum

131. Sodom Schoolhouse, 1836,
Northumberland County

132-133. Perry's Landing Marina, Erie

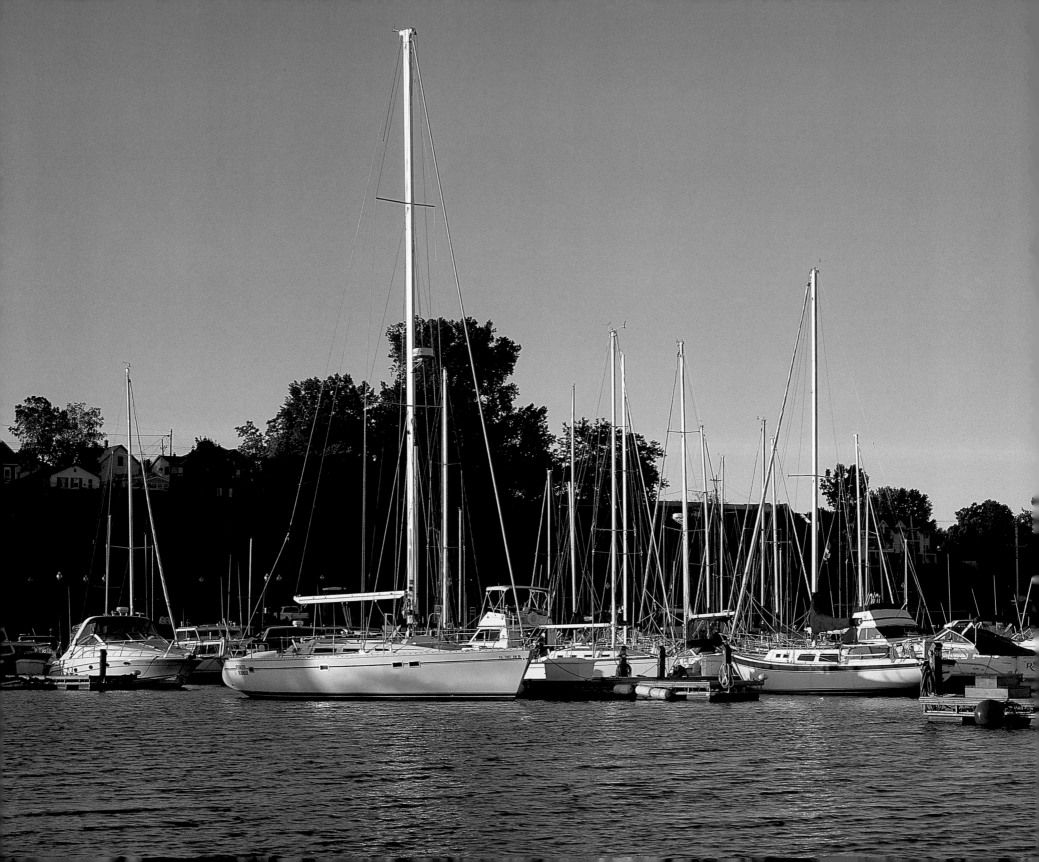

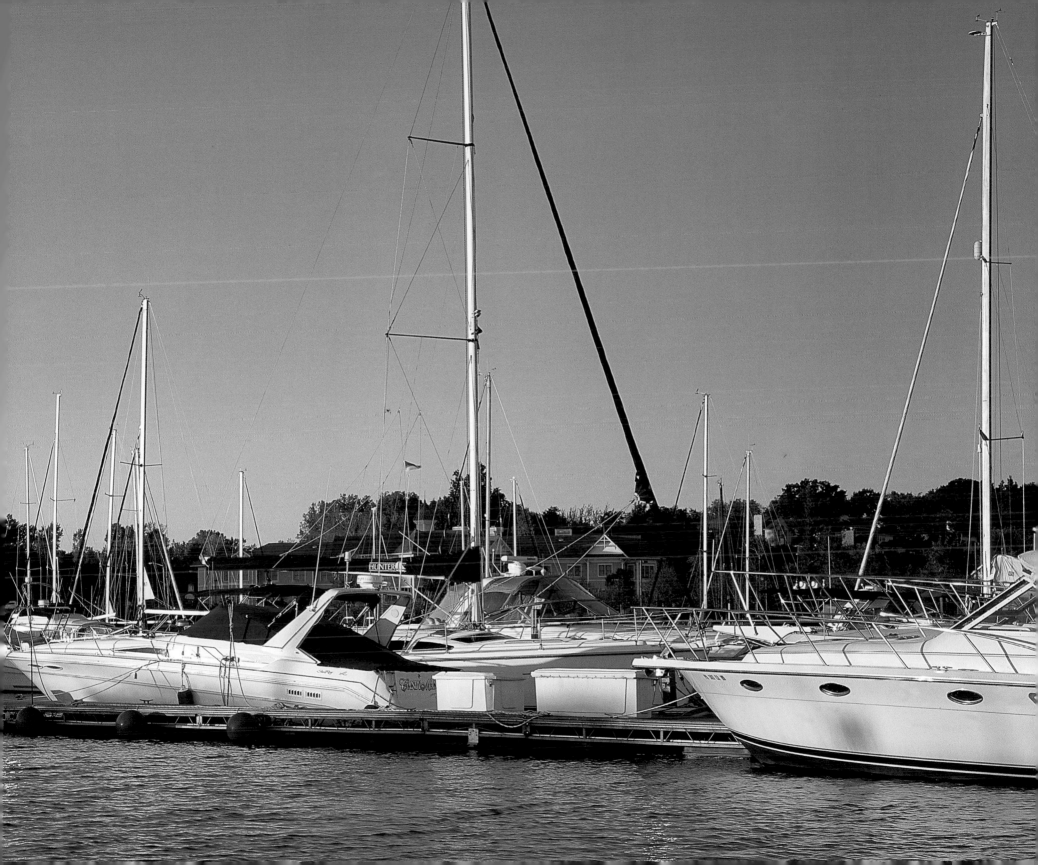

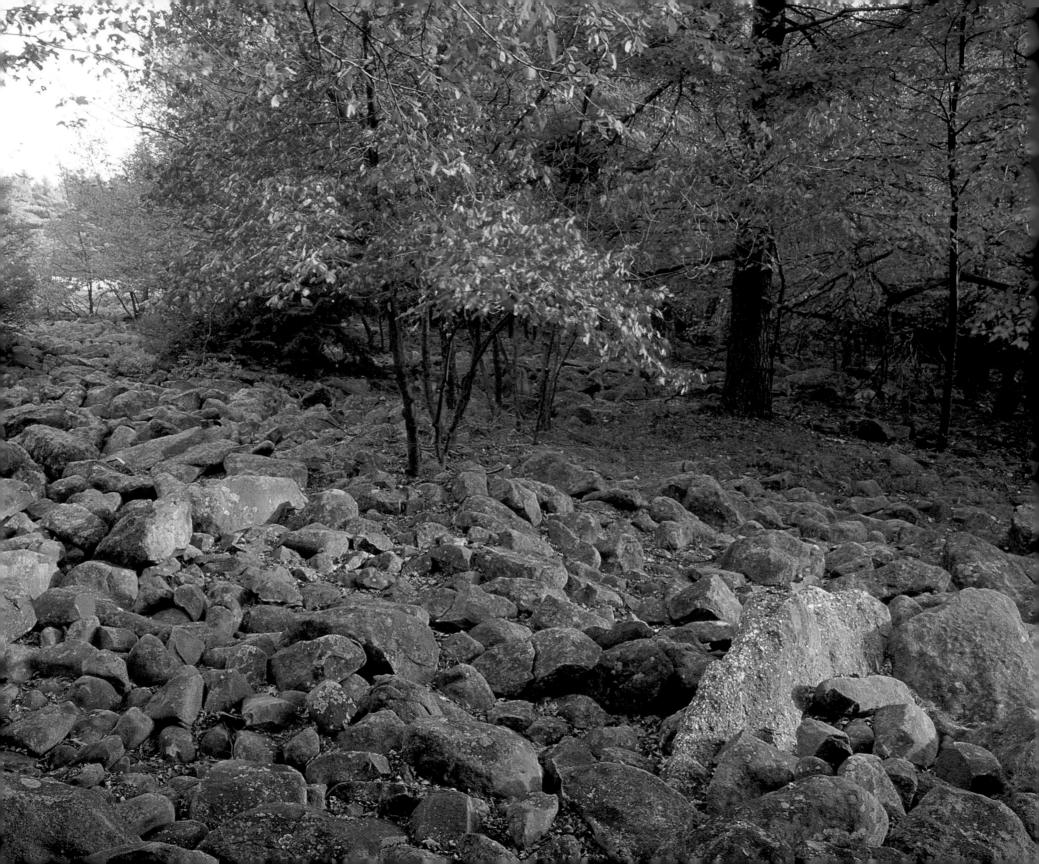

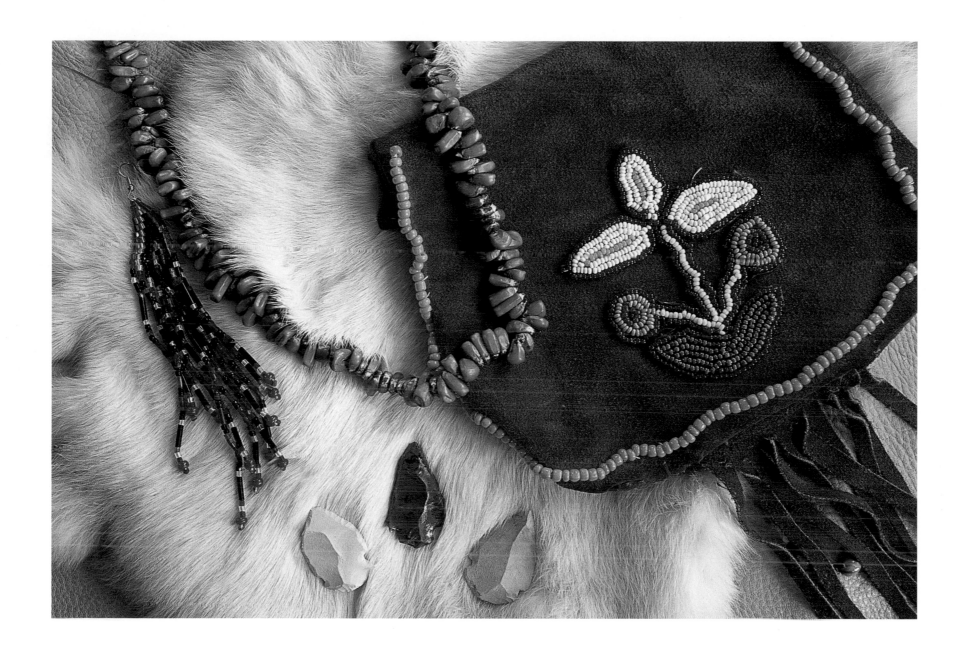

134. Boulder Field, Hickory Run State Park, Carbon County

135. The Lenni Lenape Historical Society Museum, Allentown

136. Pymatuning State Park, Crawford County